*The Campus History Series*

# WILLIAMSON COLLEGE
# OF THE TRADES

*The Campus History Series*

# WILLIAMSON COLLEGE OF THE TRADES

ANDREW MILLER
FOREWORD BY MICHAEL J. ROUNDS

ARCADIA
PUBLISHING

Published by Arcadia Publishing
Charleston, South Carolina

Printed in the United States of America

Library of Congress Control Number: 2016942422

For all general information, please contact Arcadia Publishing:
Telephone 843-853-2070
Fax 843-853-0044
E-mail sales@arcadiapublishing.com
For customer service and orders:
Toll-Free 1-888-313-2665

Visit us on the Internet at www.arcadiapublishing.com

*"The end of a matter is better than the beginning, and patience
is better than pride."*

—Ecclesiastes 7:8

# CONTENTS

# FOREWORD

At Williamson College of the Trades, we occasionally refer to ourselves as "the best trade school in the country that nobody knows about." Our hope is that this book will help remedy that situation and increase awareness of our unique story. Our mission is noble and our educational approach is unique—a college that teaches the trades while instilling character and developing leadership in its students.

Known for its first 127 years as the Williamson Free School of Mechanical Trades, Williamson has provided a free education to thousands of financially deserving young men, helping them achieve successful, fulfilling lives. We teach that character traits are just as important as trade knowledge in achieving success in life by instilling our core values of faith, integrity, diligence, excellence, and service in every student. This has been our approach since Philadelphia merchant and philanthropist Isaiah V. Williamson founded the school in 1888, and it remains so today.

We owe a great deal of gratitude to Andy Miller for tackling the assignment of compiling almost 130 years of our history into an easy-to-read book. Andy is a history instructor at Neumann University who had written a novel on the Civil War and was writing a novel on the American Revolution. He also grew up near Williamson and was familiar with our story. When Andy agreed to take on the task of writing Williamson's history into his daily schedule, the two-year project was soon under way.

Andy avoided writing a typical history book, instead writing a narrative about important times and individuals that can tell the great story of Williamson. He spent countless hours over many months in our archives doing his research and receiving much help from our archivist, Lesley Carey.

A special thanks goes to Dr. Paul Reid, former president, chancellor, and trustee, who had the vision to start this project many years ago. We are all happy to finally see a book that fulfills that vision of telling the stories of generations of exemplary Williamson men!

—Michael J. Rounds, PE
LTC (Ret.), US Army
President, Williamson College of the Trades

# ACKNOWLEDGMENTS

This book came about after a chance meeting between Williamson College of the Trades president Michael Rounds and me in a hallway at Neumann University. Mike is a West Point graduate and veteran of the elite 101st Airborne Division; we were introduced by mutual friend Dennis Murphy, who earned the Silver Star in Vietnam. I have never served in the military, but I am extremely fortunate to count many veterans among my friends, including Mike and Dennis. From that initial discussion came this history of Williamson.

A lot of people supported this project, and we all believed in it. First and foremost, I thank archivist Lesley Carey, who found materials that I never knew existed. Lesley never let me down, and this book would have taken years to complete if not for her. Mike Rounds gave me full freedom and access, always reminding me: "Let me know how I can help, Andy." His support and encouragement were the key ingredients. Greg Lindemuth, Carl Vairo, and Pauline Amalfitano were vital assets for me at Williamson. Richard Clemens, Dr. Paul Reid, and the late Wayne Watson were voices of wisdom and kindness. Cornelia Hennigan's research shined a light on the school's early years. Dr. Rosalie Mirenda, president of Neumann University, enthusiastically supported this endeavor, as did Dr. Lawrence DiPaolo and Dr. Alfred Mueller. Tish Szymurski, Mac Given, and Claudia Kovach hired me, so none of this would have happened without them. My title managers at Arcadia Publishing, Erin and Caitrin, displayed endless patience and professionalism. Finally, for inspiration I thank my friends in the Marine Corps League and especially World War II Marines Alan Macauley, Joe Hinderhofer, Jack Depew, and Jim Thomas.

There were many wonderful stories, events, and personalities that I necessarily had to omit, and I hope I will be forgiven for that. Unless otherwise noted, images appear courtesy of Williamson College of the Trades Archives.

# INTRODUCTION

Williamson College of the Trades is a three-year boarding school for young men in Delaware County, Pennsylvania. The school was founded in 1888 by Philadelphia Quaker Isaiah V. Williamson, a brilliant businessman who gave millions of dollars to charities, hospitals, and schools. Williamson's one great goal, however, was to start a school that would provide financially disadvantaged young men with free room, board, and tuition. The students could choose from several different trades, while spending half their day in the classroom and half in the shop learning from accomplished tradesmen. The rewards were very high, but it would not be easy: Students were indentured to the board of trustees for three years, and they had to follow strict rules. They would be required to stand for inspection each morning and attend daily chapel services. The young men were expected to maintain high standards of dress, behavior, and professionalism. When students broke the rules, they were held accountable. Upon graduation, they would not only have a useful trade by which they could make a living, but they would also be productive citizens.

Albert F. Graham graduated from Williamson in 1896, one of the first classes. In 1963, he was retired and living in North East, Maryland. That year, the 86-year-old alum wrote an essay for the *Williamsonian,* the school's magazine, in which he discusses the impact Williamson College of the Trades had on his life.

Graham writes that his father, William, had left Maryland in 1872 and moved to Delaware County, Pennsylvania. The following year, William married Celia O'Day, and in 1877, Albert was born. Albert's father worked at a mill where he fired the boilers and "looked after the Corliss stationary engine," Albert writes. "I remember that I used to carry his lunch down to him, he used to get me to climb a short ladder to read the steam gauge while he ate his lunch.

"On March 15, 1887 he met with an accident that took his life. That was a great shock to me. I was next to the oldest child and there were five younger, my brother Frank, who was in the '06 class at Williamson was the youngest, being 1 year, four months old at the time."

Albert was still in school when his father died, but he took on several jobs, including delivering newspapers and picking and selling fruit. Later, he "went to work in the mill where my father was killed," and he worked in other area mills. His mother applied to Williamson for him, and in April 1893, Albert started working in the carpentry shop.

"I have not forgotten what happened as we were getting our first lesson on the use of the rip saw," he recalled. "Someone in the class (I never learned who) hit Mr. Groat, our instructor, in the neck with a ball of putty. That stopped everything until he gave the class a good dressing down."

Albert became a patternmaker and after graduation worked at the Baldwin Locomotive Works in Philadelphia for 21 years. In 1917, he left Baldwin and bought a farm in Maryland, where he was still living in 1963. He worked at several other companies, ran a gas station during the Depression, and raised chickens for a time. He retired at age 76. He and his wife had three children, and Albert became licensed to preach in the Methodist Church.

His life was the perfect example of everything that Isaiah V. Williamson hoped to accomplish with his school. Albert Graham and his brother Frank were proof that Williamson College of the Trades was fulfilling its mission.

"Down through the years the things I learned at Williamson have helped me wonderfully," he writes. "The vocal music, English, elocution, literature, the use of tools, mechanical drawing, algebra, geometry and even physiology have been put to good use. In all my teaching, preaching and living, I have tried to conform to the things I learned at Williamson."

Harry Menold, class of 1909, was another young man whose life was changed by Williamson. In 1973, Menold penned a memoir of life at school entitled *Gratitude for Williamson*. In it, he writes about growing up in a small village called Mill Creek, in Huntingdon County, Pennsylvania. Mill Creek consisted of 300 people, "and the work there was nothing but common labor of work in the sand quarries.

"But in 1904 I heard of Williamson Free School and being a poor boy I made an application and I give thanks to God that I was accepted. Had I not been accepted—God only knows what I would be today, so this is why I am so grateful and thankful that I am a graduate of Williamson." Menold writes that their day began at 6:00 a.m. and ended when they went to bed at 10:00 p.m. They had a study hall period from 8:00 p.m. to 9:00 p.m. every night except weekends.

"I would consider our discipline as very severe. We all had privilege cards and for the most minor infractions of the rules in politeness, we were reported to the office and we could lose our card from a week to a month. . . . Once a year we would get overnight leave. We had to be so polite to all teachers and matrons. Smoking and staying out after lights out (10 p.m.) was dismissal from school.

"While there, we resented it very much, but today, when I look back to the school, I am very thankful for this discipline, for I feel it has been a wonderful guidance for me all through my life. I taught school for 40 years and this discipline I received at Williamson was a great help to me."

Over the decades, programs have been dropped and others added, depending on the needs of industry and the economy, and discipline is not quite what it was in 1904. Perhaps the most obvious change came in 2015, when the school officially changed its name from Williamson Free School of Mechanical Trades to Williamson College of the Trades (throughout this book, the latter name is used in all instances). Because Williamson accepts no government funding, the school has been able to maintain its founding vision and practices. The students are still young men who come from disadvantaged backgrounds. They stand for inspection and attend chapel every morning, and they are held to high standards. Williamson is still as relevant today as when it accepted its first students in 1891.

"People should know the story of what goes on here," says Williamson president Michael Rounds. "Williamson is a national treasure. We give full scholarships to underprivileged young men, we don't take a dime of government money, and we develop skilled workers and good citizens. We have a big responsibility but it's a great mission."

# *One*

# BEGINNINGS
## THE FOUNDATION

Isaiah Vansant Williamson was a man with a dream, and he was in a position to do something about it. Williamson, a Quaker businessman and philanthropist from Philadelphia, had long wanted to establish a free training school for young men who came from impoverished backgrounds and did not have the money or opportunities to learn a trade. He said that he got the idea from seeing "corner boys" all over the city—adolescents hanging around the corners of Philadelphia with no job, no schooling, and seemingly no ambition. Williamson felt that the corner boys represented a huge waste of talent and were an example of life's unfairness to the poor. If the corner boys seemed listless and idle, he believed, it was largely because society had not provided them with a fair chance. Williamson wanted to address that wrong.

"I see so many boys on the street!" he said. "I think if they had better opportunities they would make good men."

On December 1, 1888, Williamson officially founded the Williamson Free School of Mechanical Trades with a deed and an initial endowment of $2 million. A number of properties around Philadelphia were examined by the first board of trustees before they finally settled on a tract of land in Middletown Township, Delaware County, Pennsylvania. The Middletown location would prove a wise one, resting as it did on a railroad and with road links to nearby cities like Philadelphia, Chester, and Wilmington.

In March 1889, Isaiah Vansant Williamson fell ill and died, so he never lived to see his school become a reality. When Williamson College of the Trades (name officially changed in 2015) accepted its first students in 1891, it offered three-year programs in bricklaying, carpentry, machine shop, and pattern making to male students who lived on campus and received free room and board. The young men were admitted to Williamson as three-year indentured servants to the board of trustees. As those first students settled into life at Williamson during the fall of 1891, the mission had begun.

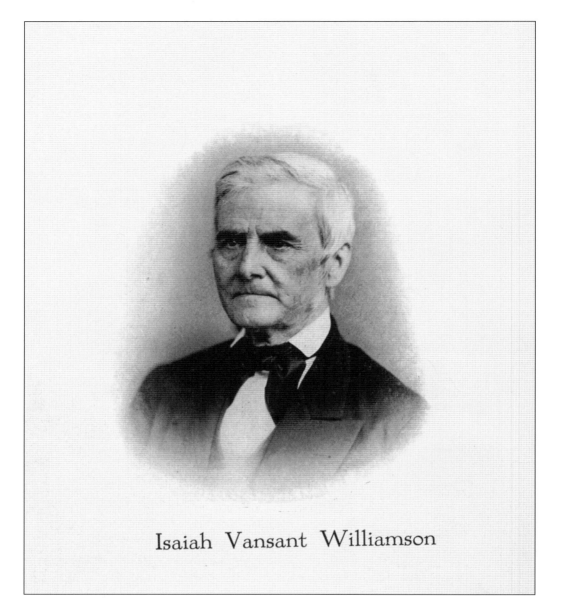

## Isaiah Vansant Williamson

Isaiah V. Williamson was born in Bucks County, Pennsylvania, in 1803. He became very wealthy through hard work and investments and retired in 1838. He understood his own talent for business and had a desire to help the disadvantaged, with a trade school being his ultimate goal. In 1888, he founded Williamson Free School of Mechanical Trades with a deed and an endowment of $2 million. He told a reporter, "It was seeing boys, ragged and barefooted, lounging on the streets, growing up with no education, no idea of usefulness, that caused me to think of founding a school where every boy could be taught some trade free of expense." He died in 1889 and was buried in Philadelphia's Mount Laurel Cemetery, but in 1892, his remains were moved to the Williamson campus and placed in a crypt in front of the Main Building.

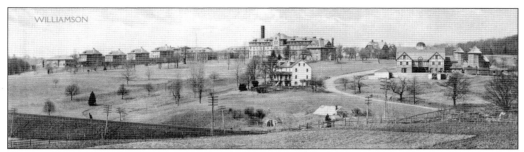

This postcard reveals Williamson College of the Trades around 1900. The Main Building is in the center, with the dormitories, or "Cottages," on the left. The farm building is on the right. The Main Building and dormitories were designed by famous Philadelphia architect Frank Furness.

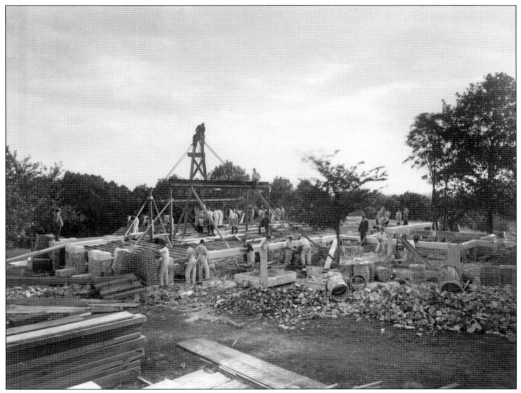

The dormitories were under construction by 1890. The building contract was awarded to West Chester, Pennsylvania, contractor Plummer Jefferis, who utilized iron and other materials to make the buildings as fireproof as possible for the time. A sidetrack was added to the railroad to facilitate the shipment of supplies. The Williamson contract was worth $250,000—around $6.5 million in 2015.

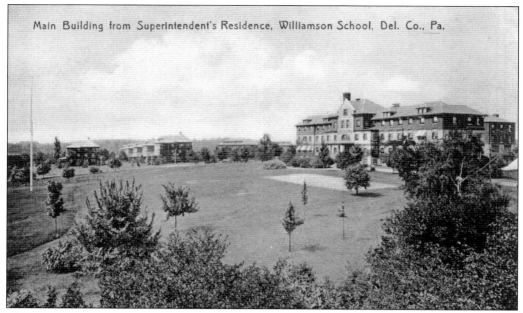

The Main Building is seen from the superintendent's campus home in 1908. Original plans called for a pool and a gymnasium to be within the Main Building; those plans were eliminated, but there was a tennis court in front of the structure, visible in this photograph.

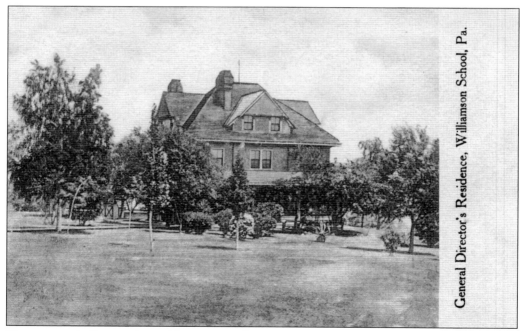

The general director's residence stood out on campus, as illustrated in this 1910 photograph. Faculty, staff, and administration lived on campus. Students helped in the construction and maintenance of campus buildings such as the one pictured.

A cottage is shown in this postcard from around 1905. All of the original cottages, or dormitories, were designed by Frank Furness, who won the Medal of Honor in the Civil War as a member of the 6th Pennsylvania Cavalry. He designed many famous buildings, including the Fisher Fine Arts Library on the campus of the University of Pennsylvania and the Pennsylvania Academy of the Fine Arts.

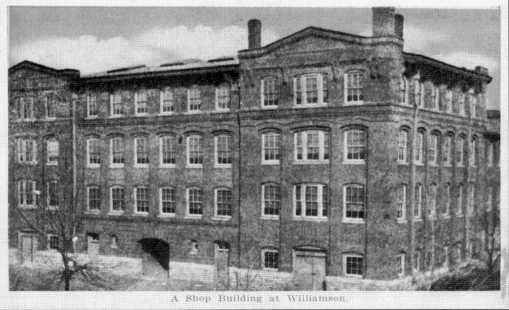

A Shop Building at Williamson.

This postcard from around 1900 focuses on the shop building. Generations of Williamson men would be trained in this building before it burned down in 1957.

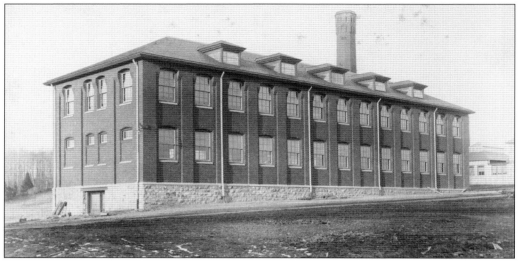

The power plant, shown here around 1910, occupies a prominent place on campus. By 1895, at least 18 buildings were completed. A 1913 atlas of Delaware County reveals a well-developed campus, including pigpens and a large dairy barn near Middletown Road.

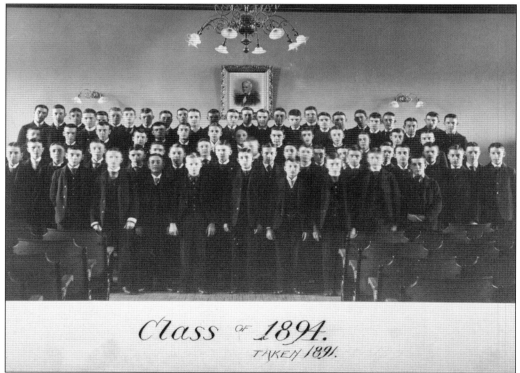

*Class* of *1894.*
TAKEN 1891.

Williamson's first students, the class of 1894, pose in the chapel in 1891. They stand below a portrait of Isaiah V. Williamson. In 1944, William Schnitzer, the class of 1894 representative, wrote of that time: "There were no movies, airplanes, radios or zippers. Vitamins and air conditioning were unknown. Women's skirts swept the floor and cigarettes used by women were *never* seen in public."

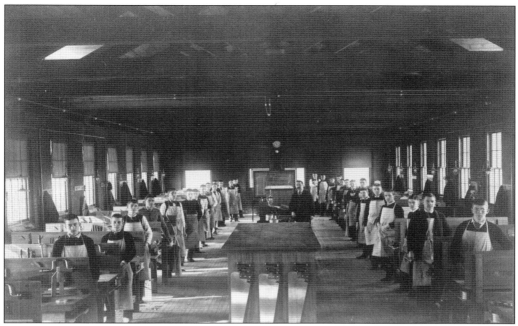

The carpentry students and their shop are pictured here in 1905. The students spent half their day in the classroom learning traditional academic subjects and the other half in the shop learning their trades.

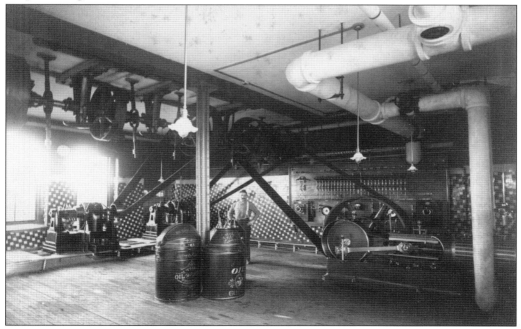

The machine shop appears in a photograph from around 1905. Each class size was carefully planned by the administration, to grow as the endowment grew. Williamson's success would not be judged by the number of students enrolled, but rather on the quality of education they received and their employment opportunities after graduation.

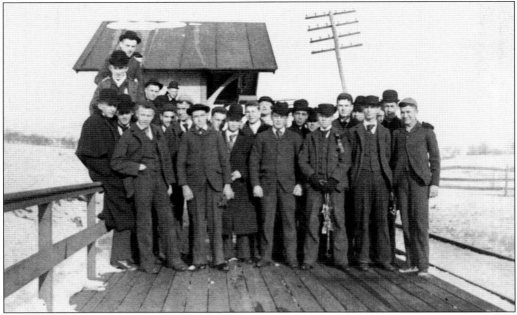

A group of students poses by the first railroad "station" around 1898. This temporary structure was replaced around 1909 with a permanent building. For many decades, the Williamson Station was the main point of entry for newly arriving students.

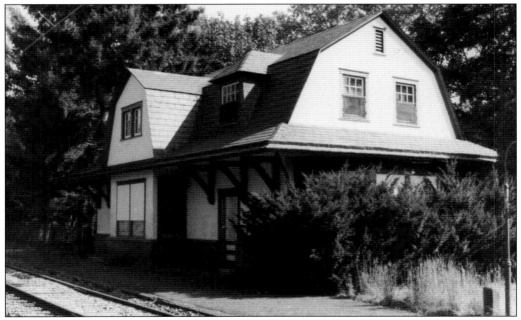

The temporary railroad station was replaced by this building around 1909. Though it was closed by the railroad in the 1980s, many alumni never forgot arriving at the station on their first day and making the long walk up Station Drive to the Main Building. The station also served as a post office from 1914 to 1963. The building is still owned by the regional rail line but remains vacant.

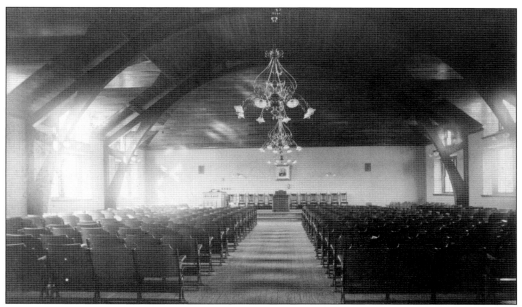

The chapel is shown here around 1895. Students were required to attend chapel each morning after inspection. The Williamson model was to provide each student with trade and academic preparation, as well as a Judeo-Christian environment that would lead to a moral and ethical life. Morning lineup and chapel remain daily requirements at Williamson.

The auditorium is arranged for the class of 1894 graduation, Williamson's first class. Philadelphia retail magnate John Wanamaker presided, and 59 young men graduated that day; their average age was 19 years and four months. A special train from Philadelphia carried about 300 people to and from the day's exercises.

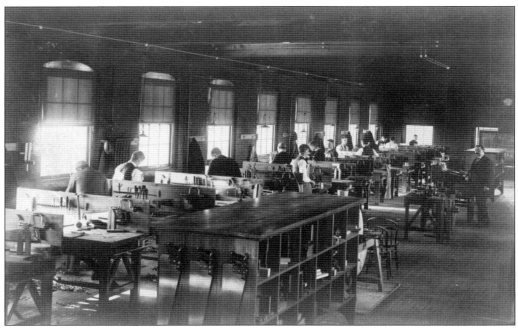

The carpentry shop is pictured here about 1910. The trustees originally had planned to have about 300 total students at Williamson, but in its first two decades, the school usually had between 240 and 250 students enrolled in all three classes.

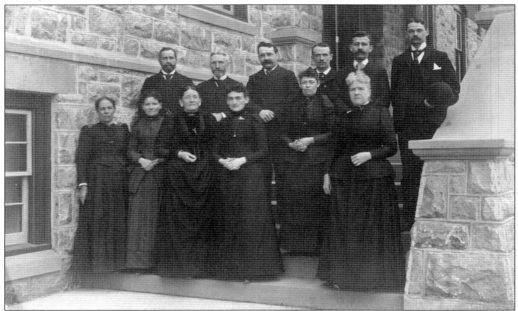

Staff members pose on the steps of the Main Building around 1895. The men provided academic and trade instruction, while the women served as matrons. The matrons lived in the cottages and supervised the students; they represented something of a home life to the young men. The matrons had the difficult task of being both friend and disciplinarian. Some inspired deep devotion from the students.

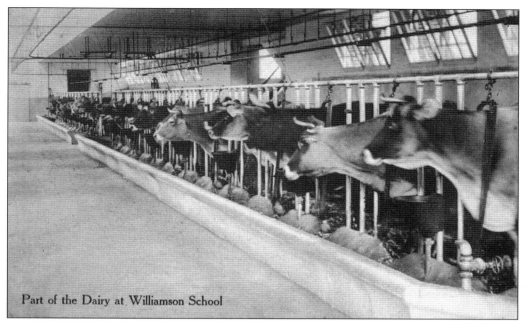

Part of the Dairy at Williamson School

This postcard from 1913 featured Williamson's cow herd. A large barn had been constructed on campus in the early 1900s, and agriculture was added to the curriculum in 1912. Ten cows were purchased for $481, which enabled Williamson to have its own dairy operation. The agriculture program would later be eliminated.

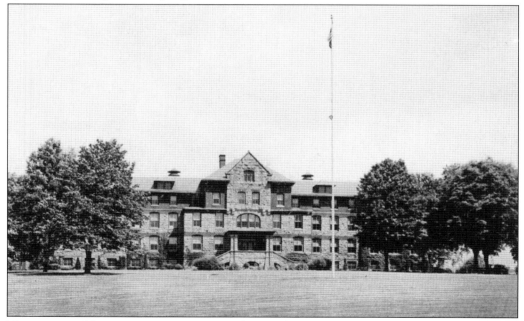

The Main Building appears on a postcard around 1900. Isaiah V. Williamson's remains lie in a crypt beneath the front entrance. Much of the land the school occupies once belonged to several farmers; in the 1830s, a chrome deposit was discovered on part of the land, and a mine operated there from the 1850s to 1876.

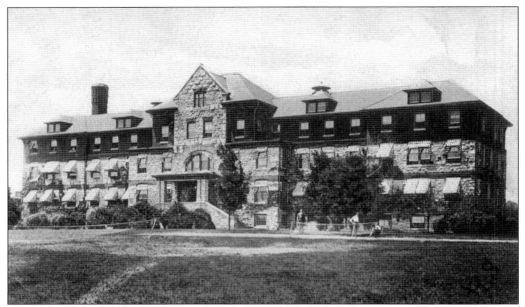

This view of the Main Building is on a 1907 postcard. This was apparently sent by a Williamson student to a young woman. The message reads, "You are a peach for not sticking to your promise Sunday night." Local towns like Media, Chester, and Glen Riddle were off-limits to the students most of the time, though they often found ways to visit them clandestinely.

These Williamson students pose for a 1908 photograph, which was turned into a postcard. In a timeless message from college students, the sender writes to his family in Elizabethtown, Pennsylvania: "How do you like this? Please send me some money. I will need it now."

# *Two*

# FINDING ITS PLACE
## 1890–1920

Williamson's board of trustees would manage the school's endowment and all major issues, but day-to-day leadership was divided among officers, who supervised student life, and teachers, who delivered training and academic instruction. Until 1961, the students were of high school age. The first graduates' average age, in 1894, was 19 years and four months.

The United States entered World War I in 1917, and while there is no clear record of how many Williamson men joined the US military, the nation's war effort was enthusiastically backed by students, administration, and alumni. School publications list dozens of Williamson students and alumni who were in the military, many serving in France with the American Expeditionary Forces. Six Williamson men died in World War I.

As the war concluded, the world was struck by the influenza pandemic of 1918, which killed at least 40 million people. Williamson was not immune; the campus was quarantined that year, as almost everyone fell ill. An instructor died from the flu, and Williamson students helped dig graves in Delaware County for flu victims. One alum remembered visiting a nearby school for the disabled and looking in the window of a large building there. "The floor was covered with corpses laid in neat rows," he wrote many years later.

Despite war and plague, life at Williamson went on. Sixty young men graduated in 1918—6 agriculturists, 11 bricklayers, 13 carpenters, 10 engineers, 12 machinists, and 8 patternmakers. The average age was 20 years and 10 months at graduation. Under a government tuition reimbursement program, many veterans attended Williamson in order to learn a trade. There were 126 of them at the school in 1921, in addition to 190 regular students.

Life at Williamson was rigorous and demanding, but they were well prepared for life after graduation. Through hard work and careful stewardship, the young trade school had flourished and found its place.

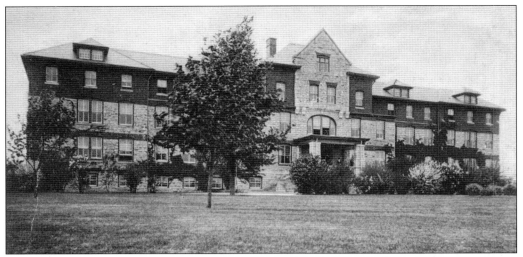

The Main Building is shown in a postcard dated 1907. Early Williamson graduates had opportunities but also faced problems upon graduation. "Organized labor was decidedly antagonistic to the Williamson idea of vocational training," writes William Schnitzer, 1894 class representative, in the May 1944 *Williamsonian*. "There were no 'glad hands' extended to the pioneer class, but rather, obstacles and discouraging propaganda were encountered. . . . We depended on our own initiative for success."

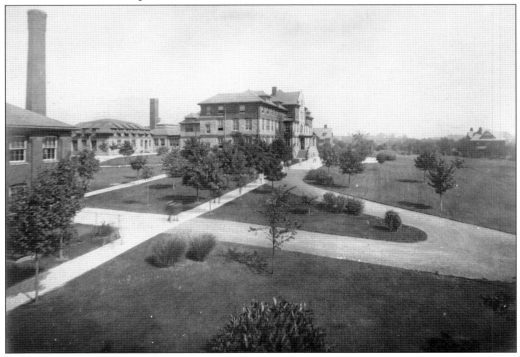

When Williamson accepted its first students in 1891, Middletown Township was still rural and agricultural, as illustrated in this c. 1910 photograph. The land had belonged to the Lenape before the first Europeans arrived; the Lenape word for goose, *wawa*, later became the name for a popular convenience store chain that started in Delaware County.

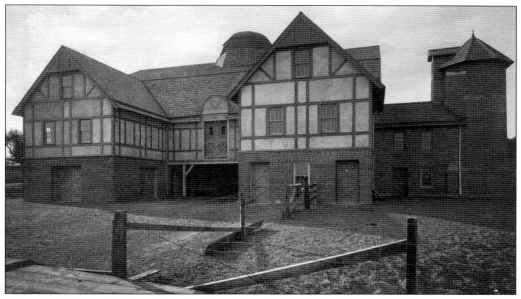

The rear of the agriculture barn is shown here in 1898. By the early 1920s, Williamson had graduated 75 "scientific agriculturists." The program was discontinued in 1924, however, because agriculture was classified as a semiskilled trade rather than as a skilled one; earning potential was considerably lower than in the other trades. Five seniors completed the program in 1924 and one in 1925 before it was completely ended.

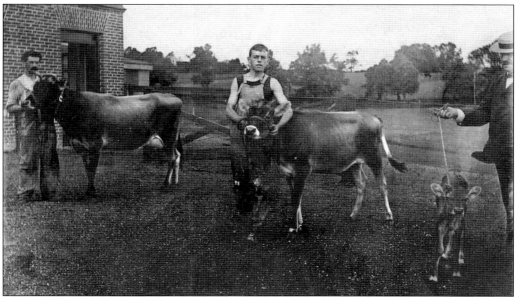

In this photograph from around 1900, an agriculture student poses with instructors, as well as two cows and a calf. One "aggie" student, Harold Snively, was happy to help care for the sick during the influenza pandemic. "Director James A. Pratt called for volunteers to care for the stricken," Snively remembers in a 1976 letter to school administrators in which he shares memories of the pandemic. "That was for me. I was taking the Agriculture course and never did like that 4 a.m. dairy assignment."

Going to Oregon in the Spring, out to
Len Homestead and build his house
Only 8 mo. and 2 weeks till I Graduate. Mar 26
1910. C.B.G.

This postcard from July 1909 shows a dormitory at Williamson. The sender writes on the back: "I know it is your time to write, but I want you to know that I'm not enjoying school life these hot days, especially in the classroom."

The power plant is the focus of this 1910 photograph. Jonathan Bright, the editor of the 1910 *Mechanic*, Williamson's yearbook, notes that in 1891 all students were "assigned to the woodworking department for a six-months' course in elementary joinery. This plan was abandoned for the one now in use by which all of the incoming pupils are admitted for a specific trade and devote all their shop time to it."

The interior of the machine shop is shown in 1896, with the tables and instruments set up to teach "gearing" to the young machinists. By 1896, Williamson was already a success. The first three classes—1894, 1895, and 1896—totaled 151 students. In the following years, the average class size was around 80, but in 1914, the school received 434 applications; in 1916, it received 515 applications.

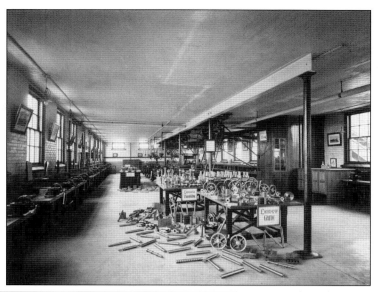

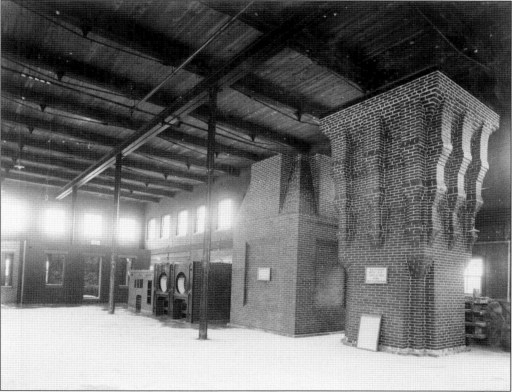

The interior of the brick shop was photographed in 1896. Jonathan Bright, editor of the 1910 *Mechanic*, writes that from 1905 through 1909 Williamson graduated 62 bricklayers, who on average made $4.64 for a work day of eight hours. According to the US Department of Labor statistics, $4 in 1913 (the earliest date available for comparison) was worth $95.60 in 2015.

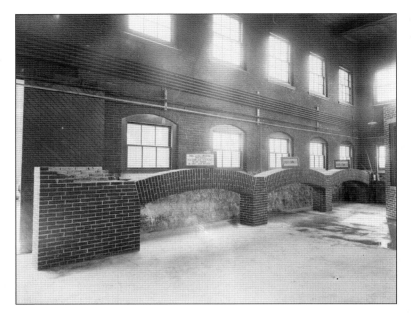

Williamson students were proud of their proficiency, as illustrated by this photograph of the brick shop in 1896. The students who built these noted their completion times on the signs above the arches; each was constructed in approximately three hours.

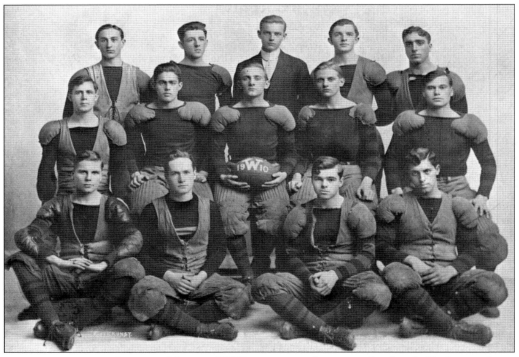

It was not easy to be an athlete at Williamson, as these varsity football players from 1910 surely could attest. Students had a rigorous daily schedule and also worked on construction and maintenance projects on campus. These young men display great pride in their school and their sport, but the administration initially looked upon football as being too violent.

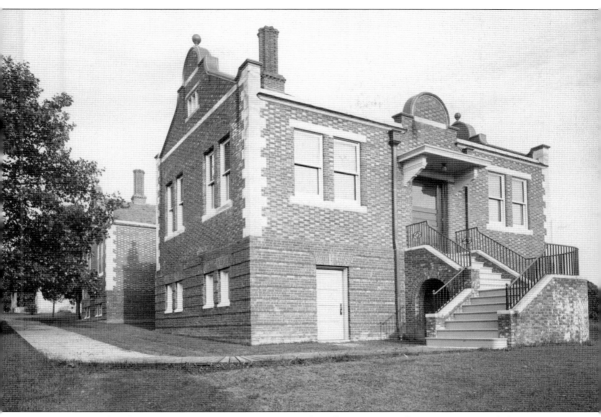

Contagious diseases were a constant worry, and Williamson's infirmary, pictured here in 1915, was crowded with the sick during the influenza pandemic of 1918. "All classes and activities were suspended and the premises quarantined. Few were permitted to enter or leave," recalls Frank Barsby, class of 1920, in the 1976 letter to Williamson administrators regarding the pandemic. The healthy "were pressed into service as attendants and soon many of the cottages were filled with the sick. Elwyn School was far worse off and many died. Caskets were unobtainable and pine boxes were constructed. A number of our boys volunteered to dig a mass grave over there and would accept no pay for their labor." Barsby helped prepare the body of an instructor who died of the flu. "This was a harrowing experience for I had never before been present at the death of a human being," he wrote. The infirmary later became a dormitory.

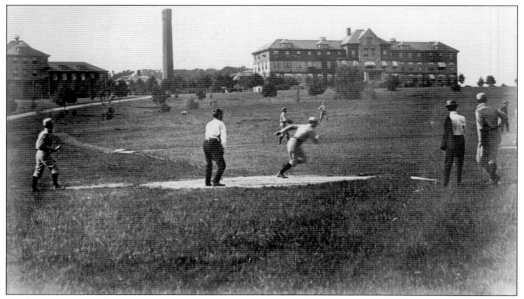

In the spring and summer, students played baseball in front of the Main Building, as in this 1910 photograph. When given permission, students could visit Media or the city of Chester, which was alive with restaurants, bars, theaters, and other places where young men could have fun and relax.

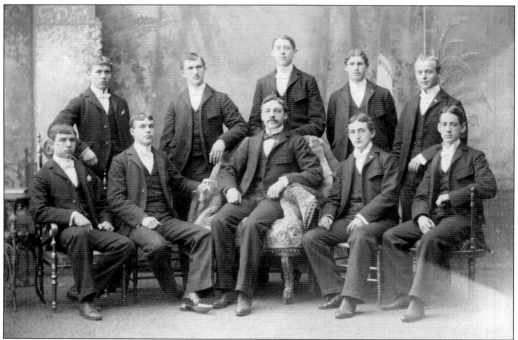

Music has always been a major part of student life at Williamson, as reflected in this photograph of the glee club from 1895. Activities like the glee club and the yearbook helped keep the students busy and productive. Some of the clubs often gave performances off campus.

June 2, 1933
Tokai Middle School
Nagoya, Japan

To our Friends
Williamson Free School
of Mechanical Trades,
Del. Co., Pennsylvania

In response to your message for friendship exchange, we feel very happy to reciprocate our sincere greetings in order to reassure ourselves of the cordial relations that have existed between the two nations since the opening of our country through the kind and generous offices of your great countrymen.

It is true, the state of affairs in the world is no longer what it used to be more than seventy years ago, and to a superficial observer it may appear that the trend of events has taken quite a different course.

But this is simply a visionary view of the situation; behind the passing storm that interrupts our clear sight from time to time, the sun of truth ever remains bright.

There can be no true lasting peace

This letter was sent to Williamson from Tokai Middle School in Nagoya, Japan, in June 1933. It was in response to efforts by Williamson students to make a connection with their peers overseas. In the letter, the Japanese students note the growing tensions between America and their country but express hope for harmony and understanding. The letter came in a small book in which the Tokai students signed their names in Japanese and in English. Eight years after this letter was received at Williamson, the two nations would be locked in a massive world war that would cost the lives of many millions. Sixteen men from Williamson would die in World War II. Nagoya, Japan, would be firebombed and largely destroyed in American bombing raids.

without good understanding among the nations, and it is the duty of every nation to help improve it. This task devolves especially upon the rising generation, to whom the world always belongs; the dawn of a new era must be brought about by us who are to inherit the earth. In this conviction we can not but grasp the warm hand you have just extended with a view to inaugurating the advent of a reign of peace and good will among men. This fact has been amply proved by what has been accomplished quite recently at a conference in your White House between your magistrate and our delegates.

Sincerely hoping that relations will be bettered by this movement,

The Tokai Students

# *Three*

# HARD WORK AND DIFFICULT TIMES
## 1920–1940

The Great Depression officially began in 1929 and lasted until America's involvement in World War II. Williamson made it through this harrowing period by keeping its investments conservative, streamlining programs and eliminating others, and appealing to alumni for guidance and contributions. By all accounts, Williamson was never in any special financial danger directly related to the Depression. Alumni were generous throughout the 1930s, and the school's excellent reputation worked in its favor, such as in 1931 when the State Forestry Service donated 2,000 spruce and pine trees to the campus.

In 1930, the campus drinking water became an issue, and it was thought that the pigpens and dairy were causing contamination. As a result, the school sold its dairy herd to a farm school for $1,800 and its pigs to a local man for $141. It also built a new sewage treatment plant, with students performing $2,500 of the work.

Applications and enrollment remained high, and Pres. Franklin Roosevelt's New Deal programs of the 1930s provided Williamson students with many opportunities. In the 1936 *Mechanic*, brick masonry instructor Clement E. Van Lott writes to the graduating seniors: "During the past three years there have been so many pessimistic viewpoints about the possibilities of getting jobs that I believe you have made efforts in school which would not be normal in common times." Williamson students were different indeed but in positive ways. That same year, the bus company that drove the school's sports teams to and from games gave Williamson a hefty discount because its students were so kind and courteous and treated the company's property with respect.

The themes of patriotism and pride in the United States permeated Williamson culture in the 1930s. The world was moving toward an even greater war by then, and members of the Williamson student body were well aware of the risks they were facing as young men. Depression would be followed by world war, and Williamson would meet the challenges of both.

Generations of Williamson men always remembered their first day on campus and that long walk from the train station to the Main Building. That walkway is shown on a postcard from the early 1900s. This view is looking down from the Main Building in the direction of the station. The gravel path, known as Station Drive, was carefully maintained by the students.

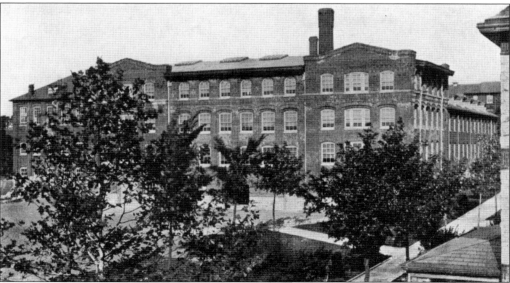

This is another view of the shop building at Williamson, from an early-1900s postcard. After World War I, the school participated in a federal program that reimbursed any school that accepted veterans. During and after the war, trade schools like Williamson were in high demand.

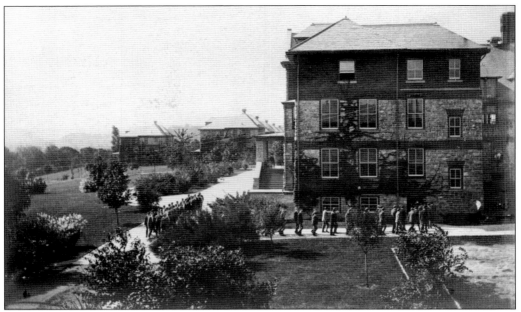

Williamson College of the Trades was built on the Quaker beliefs of education and hard work. However, for structure, the school followed a somewhat military model. In this photograph from around 1900, students leave their daily inspection in front of the Main Building and file into the dining hall as their day gets started. The dormitories are on the left.

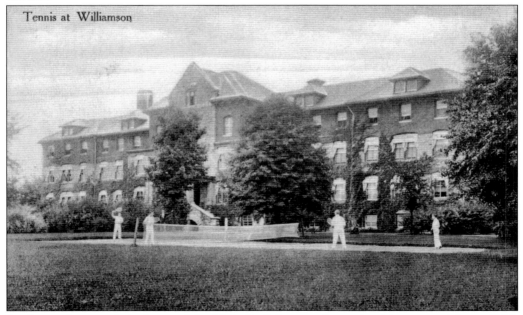

Tennis at Williamson

Students play tennis in front of the Main Building, as shown in this postcard from 1903. The tennis courts would later be eliminated. The sender of the postcard was a young man from Altoona, which was very typical of Williamson students at the time. Almost all of them came from Chester, Philadelphia, or the industrial towns of Pennsylvania.

Williamson painters pose with a canine friend in front of Isaiah V. Williamson's tomb in the 1930s. During the Depression, America's gross domestic product fell by nearly 50 percent. Unemployment, however, was the real hallmark of the Depression, and Williamson students worked especially hard to increase their chances of employment upon graduation.

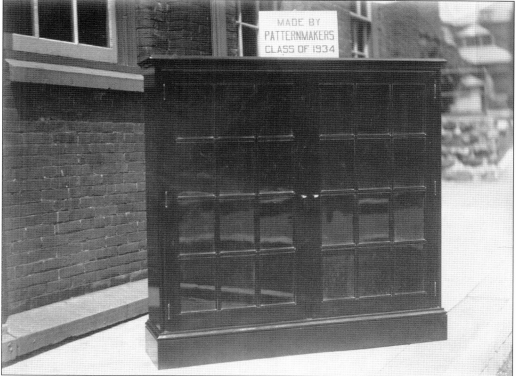

The patternmakers in Williamson's class of 1934 proudly display a cabinet they constructed. Patternmaking was discontinued in 1938. The cost of modernizing school facilities and keeping up with the rapidly evolving industry did not match job opportunities for graduating seniors in patternmaking. In 47 years, Williamson graduated 349 patternmakers.

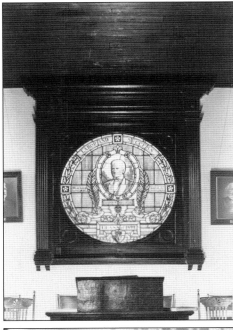

This 1937 photograph shows the chapel window, a gift to the school from the class of 1899. The stained-glass image of founder Isaiah V. Williamson features the motto "Labor and Success."

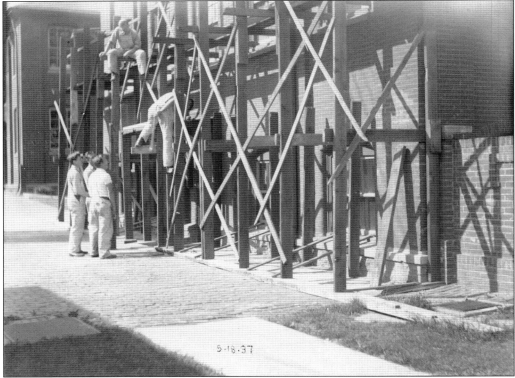

5-18-37

Williamson students work on a campus building in this photograph dated May 18, 1937. Structures on campus needed constant repair and maintenance, providing the students with a practically endless source of experiential work.

These photographs show Shrigley Library in the late 1930s. In addition to their shop studies, all Williamson students took traditional subjects like English and history. In 1935, the chairman of the board of trustees, Isaac H. Clothier, recommended the school change its basic program from three years to four, with a shorter school day. Clothier said that a four-year program would allow for better education in the trades and more "cultural development to which employers generally attach much importance today in selecting personnel." The trustees rejected his proposal because a four-year program would limit how many students could be accepted into the school and increase the cost per student. It would also violate Williamson's emphasis on vocational trades, thus altering the school's basic mission, the trustees said.

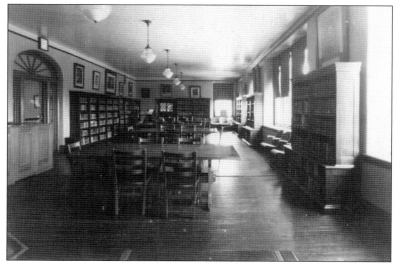

The entrance to the chapel is shown in a 1936 photograph, when fascism and tyranny were on the rise in the world. Patriotism, pride, and faith permeated Williamson culture in the 1930s, which is obvious from all contemporary school publications.

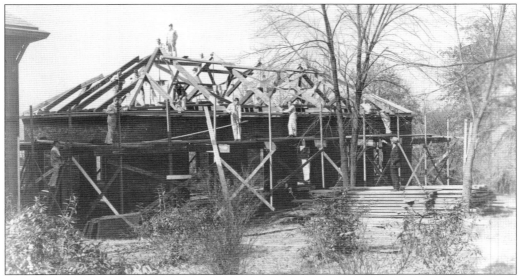

Williamson students constructed the laundry in 1938, the kind of project Williamson students have always done. One 1918 graduate noted that his class built "an addition to the engine room, and installed a new Ball engine and generator, placed an oil grinder in the pattern shop, helped to complete the foundry, built a pump house, several garages and other small buildings."

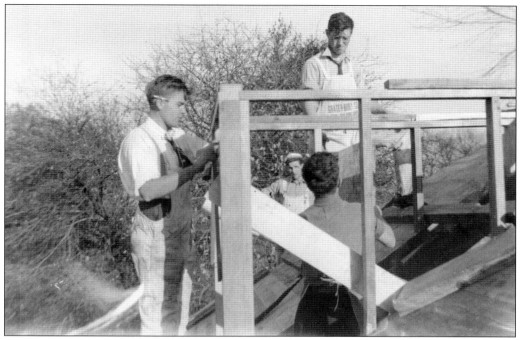

These are close-up views of Williamson students building the laundry in 1938. They worked under the supervision of instructors and experienced tradesmen. At Williamson in 1938, as students and staff kept an anxious eye on world affairs, there was a series of debates on campus. According to the *Williamsonian*, the senior machinists debated: "Resolved, that the government should own and operate the telegraph and telephone systems of the country." The following week students debated: "Resolved, that immigration is detrimental to the United States." Also in 1938, the glee club "gave its widely-advertised concert at Glenolden Presbyterian Church," and the club "impressed a large audience decidedly with its excellent harmony."

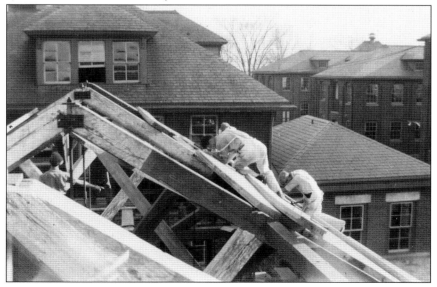

The completed laundry is displayed in this 1938 photograph. In the 1938 *Mechanic*, Pres. J. Harvey Biers alludes to the volatile world situation when he writes, "The world today needs true men; those who will work to safeguard the liberties of the people."

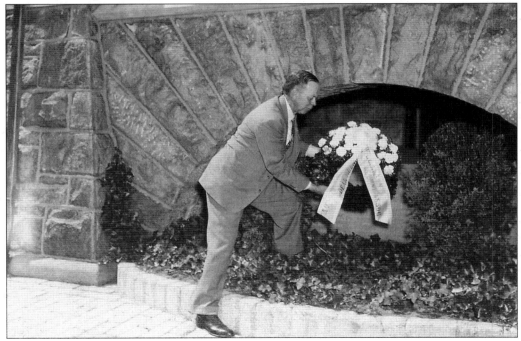

An alum places a wreath on the tomb of Isaiah V. Williamson in this 1940 photograph. The school was staying true to its founder's vision. The year before this photograph was taken, 58 new students arrived on campus at "Willie Tech." Pres. J. Harvey Byers told them, "Not only a mechanic or brilliant student is made at Williamson, but a Christian Gentleman."

The class of 1912 is pictured in front of the Main Building in June 1937 for their 25th reunion. Two years after these men graduated from Williamson, World War I started in Europe. One of their classmates, Bion McClellan, a patternmaker from Mount Jewett, Pennsylvania, was killed during the war. McClellan's nickname at Williamson had been "Irish," and he especially enjoyed reading his mail while a student.

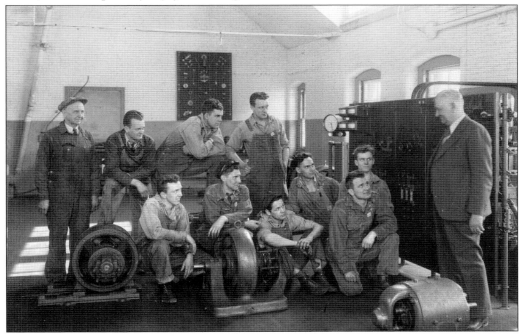

Machine students are shown with instructors in a c. 1938 photograph. Camaraderie and affection are evident on their faces. Staff, administration, and faculty knew that these young men were heading out to the continuing Depression and probably to another war.

Pictured is the carpentry shop as it appeared in the spring of 1940. That September, Williamson welcomed a new class of 46 students, who came from 16 Pennsylvania counties. Philadelphia had the most in that class, with Schuylkill County coming in second.

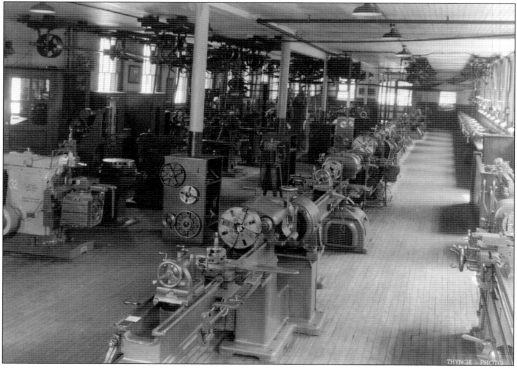

The machine shop was photographed in the spring of 1940. That June, student Bill Schnitzer wrote in the *Williamsonian*: "In the welter of sad news from Europe we should be happy and thankful that we still have the opportunity to roam around in freedom and that our homes, our church, and all our schools are intact from danger."

# *Four*

# COURAGE AND SACRIFICE
## THE 1940s

In the Archives Room at Williamson College of the Trades is a small box of photographs, letters, and personal belongings donated to the school long ago. On the inside cover of a scrapbook is taped a faded black-and-white photograph of a young man striking a bodybuilder pose.

Edward Nuneviller's nicknames while a student at Williamson were "Ed," "Atlas" in recognition of his physique, and "Noonie." A Philadelphia native, Nuneviller was a brickmason in the class of 1938. By 1944, he was flying a P-47 Thunderbolt fighter plane and was based in Italy. In a letter from his air base dated May 12, 1944, he writes his mother to reassure her. But he also hopes that she might shop for him at Lit Brothers, a department store in Philadelphia. He writes:

> Just a few more words to let you know I'm still taking things easy. I still haven't flown much lately and still have six missions.
>
> Things are pretty quiet around camp, but the past few days I spent building a set of rings to exercise with.
>
> I was going to write and ask everyone to send something, but it seems like it might be a lot of trouble.
>
> You can go into Lits and get something each week. Try to get larger boxes and good stuff. It will run into money, so each time keep track of it and subtract it from my checks. I guess at that, a box of candy every two weeks would be enough. Try to send me a box of candy when you get the chance.
>
> Well, write often and don't forget that big box of candy.
>
> Love,
>
> Ed.
>
> Remember me to everyone—Grandmother and Grandpop.

Five days later, Nuneviller failed to return after a mission over the Bologna Marshalling Yards. He is memorialized on the Tablets of the Missing at the Sicily-Rome American Cemetery.

Edward Nuneviller was one of 16 Williamson men who died in World War II, the saddest of the many ways in which the decade touched Williamson and shaped its future.

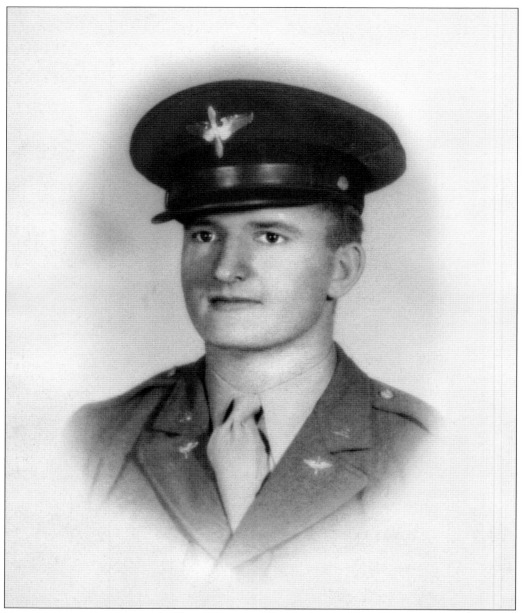

Edward Nuneviller, class of 1938, is pictured in his Army Air Forces uniform. He failed to return from a mission escorting bombers in Italy in 1944; his mother received a telegram from the government reporting that her son was missing. That original telegram, plus many of Nuneviller's medals, letters, and mementoes, is in the Williamson archives. Nuneviller's death was a tragic loss for his family and his country; he was one of 16 Williamson men who died in World War II. And they were among the dozens of Williamson students or graduates who served in every corner of the world during the war. Many left school and entered the military before they graduated. So many Williamson men were in the war, in fact, that there were not enough students left in the classes of 1945 or 1946 to hold either a commencement ceremony or publish a yearbook.

Painting and decorating students get some tips from an instructor in this photograph from the early 1940s. The US government took an interest in trade schools like Williamson, as mechanical and technical skills would soon be in demand as a result of the coming war.

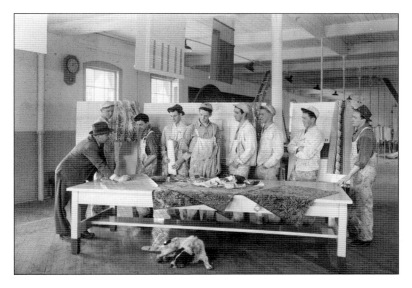

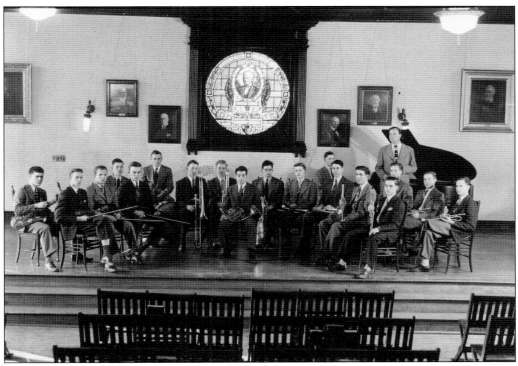

The chapel orchestra gathers under the image of founder Isaiah V. Williamson in this photograph taken around 1941. In addition to varsity sports and music, students could participate in publications, club sports, managing a sport, or managing the campus store.

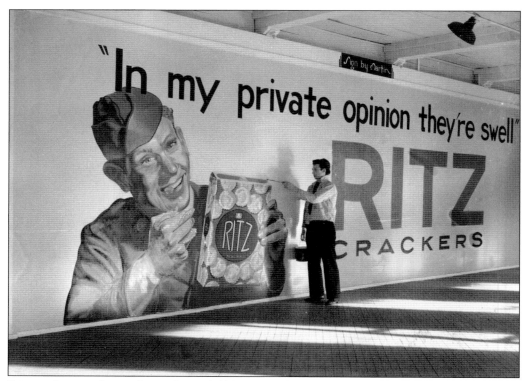

Decorating students show their skill by completing billboard-size advertisements for popular American brands. Both photographs are probably from the early 1940s. The advertisement for Ritz crackers clearly took place during the war, as evidenced by the image and slogan referring to a "private" soldier. In the 1942 *Mechanic*, the decorating seniors indicate that they fully understand what they are confronting when they write, "We have a great problem staring us in the face, which might call some of us away from our trade. If we are called into service, we can do better than our best, and when the Armistice is called, we have our Decorating to be our guide."

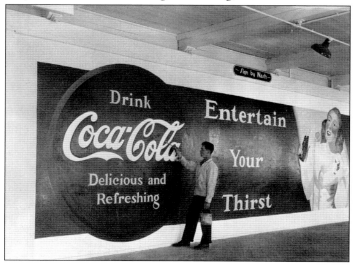

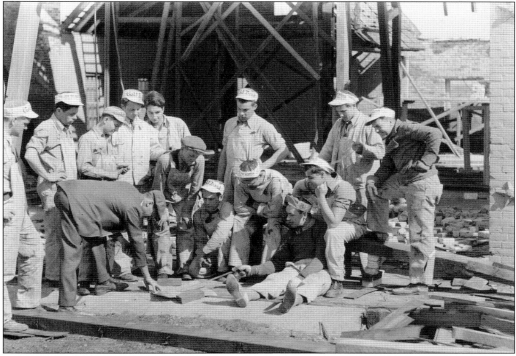

Carpentry students are at work on a campus construction project around 1941. Students kept an anxious eye on world events, but life went on as usual at Williamson. Campus buildings and grounds required constant maintenance, most of which was performed by the students.

Students talk at the entrance to the machine shop in this photograph from the early 1940s. During World War II, the Williamson machine shop received many contracts from the government for war supplies, such as making parts for machine guns.

In this photograph from the late 1930s, brick and masonry students pose with instructor Clement E. Van Lott, who is seated at far right. Seated to the left of Van Lott is Philadelphia native Edward Nuneviller, who served as a fighter pilot in World War II and went missing in action in 1944.

The dining hall is set up for Alumni Day 1941. Throughout the Depression, the board of trustees kept its investments conservative, relying on the school's endowment but also on the generosity of alumni and private and corporate donors.

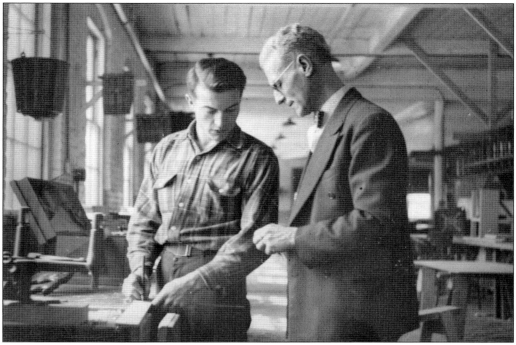

H. Fred Heckler grew up in Lansdale, Pennsylvania, and came to Williamson in 1913. After graduating in 1917, Heckler plied his trades as a carpenter and a draftsman before returning to teach carpentry at Williamson from 1935 to 1965. He is shown here in the 1940s teaching a young man in the carpentry shop.

Instructor H. Fred Heckler works with carpentry students on a campus construction project. When he arrived on campus in 1913, Heckler had to spend his first year as a "rook," a requirement before a boy could begin his trade education. Rooks generally performed manual labor around campus.

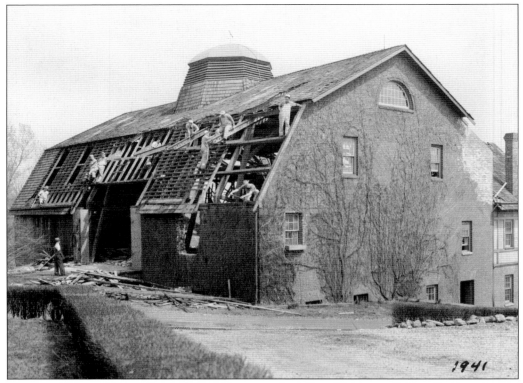

These photographs from 1941 show the old agriculture barn being renovated by Williamson students. The barn would be turned into Alumni Hall, but before that could happen, the exterior had to be altered and the interior completely rebuilt. The project was finally completed in 1943 and involved students from all of Williamson's shops. Williamson's cow herd had been sold decades earlier and agriculture discontinued in the 1920s, so the school had no need of a barn. Solidly constructed and built to last, Alumni Hall occupied a prominent place on campus. After the renovations, the structure would stand as a testament to the skill of Williamson tradesmen.

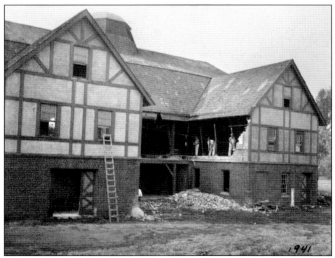

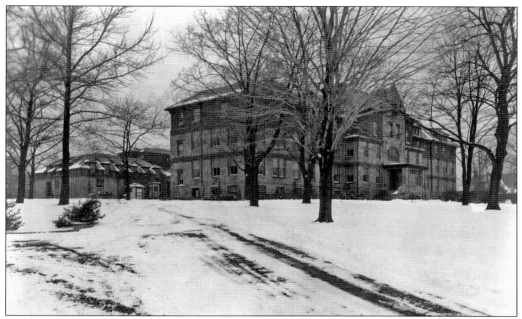

The Main Building is pictured on a snowy day in February 1941. George Heckler, class of 1942 and later a president and trustee of Williamson College of the Trades, took this and many of the campus photographs from the late 1930s and through the 1940s. His albums are a part of the school's archives.

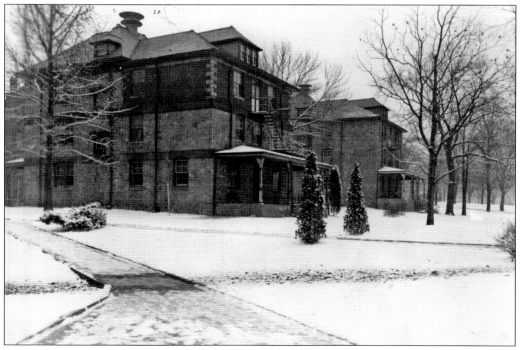

Two of the cottages are shown in February 1941. The fire escapes were not part of the original construction but were added later.

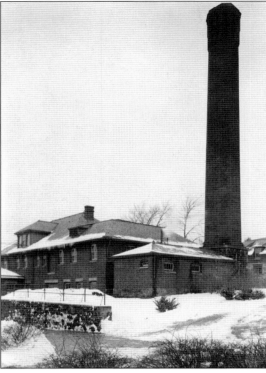

This February 1941 photograph shows the power plant. Students operating the power plant provided most of the power, water, and waste disposal to the Williamson campus. The facility was state of the art when it was originally constructed.

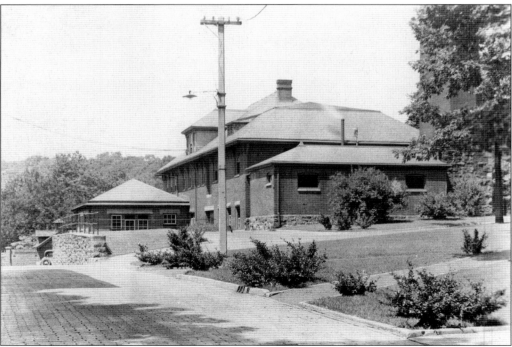

This is a closer view of the power plant, taken in the summer of 1941. Power plant was always a very popular subject choice among Williamson freshmen.

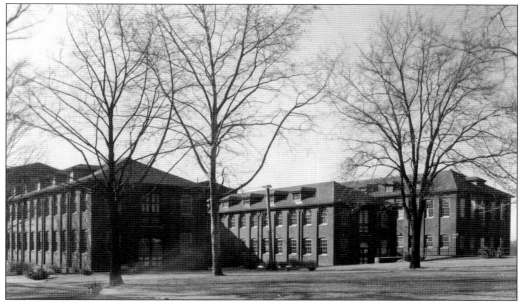

Most of the action at Williamson took place in the machine shops, pictured here in April 1941. The building in which they were housed was part of the school's original construction. The devastating fire of 1957 would destroy the shops but spare the power plant, which stood separately.

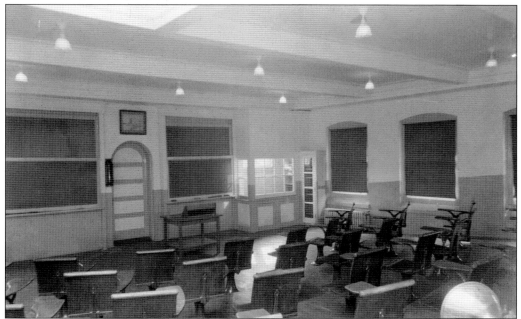

In November 1941, the editor of the *Williamsonian* had written of world events: "No longer is war improbable, rather, harsh as it may sound, it is inevitable. To prepare in time we need the full cooperation of every industry and every individual. Individual gains must be placed second; our country first." This Williamson classroom is pictured in December 1941, the month America entered World War II.

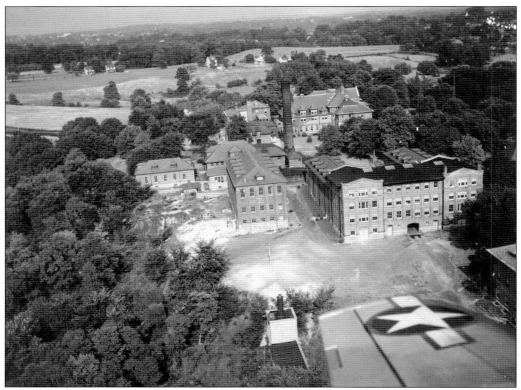

Williamson's involvement with the war effort actually began in the late 1930s, when a government aerial photography program briefly came to the school. George Heckler went up in one of the planes and took photographs of the school. This photograph from the early 1940s shows the back of Williamson's campus. The plane's wing, with its Army Air Forces roundel, is at the bottom of the photograph.

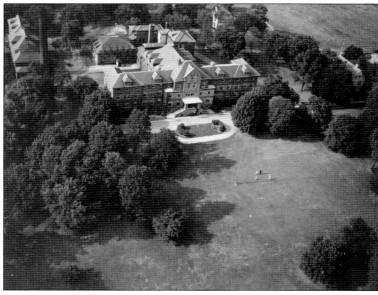

This is another George Heckler photograph, this time of the Main Building during the war years. In September 1941, air-raid drills were conducted at Williamson, and in December 1941, many employees were required to take first aid courses. The campus community also practiced blackout procedures.

George Heckler took this photograph of the campus in the early 1940s. Even before America entered the war, blood drives were held at Williamson, an auxiliary fire company was formed, and the campus was classified as an air-raid shelter.

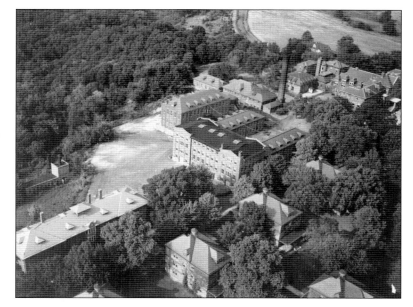

This view of the cottages and the walkway leading to the Main Building was taken on a quiet summer day in 1942. So many students were leaving Williamson for military service, the board of trustees voted to issue a certificate of completion to any Williamson student who finished two years of study.

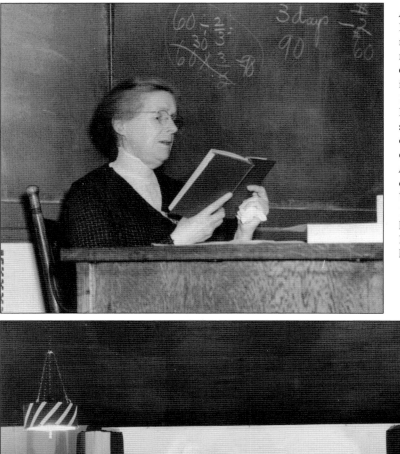

A. Blanche Derrickson, a math instructor, reads from *A Christmas Carol* in this December 1942 photograph. Derrickson also served as principal of the academic department. According to a contemporary *Williamsonian,* in 1940 she fell in the lobby of the Main Building and broke her wrist.

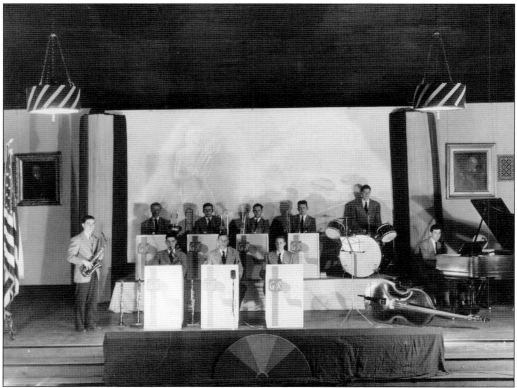

The dance band stops playing long enough to pose for this photograph in 1942. The war impacted the school in many ways; due to rationing, there was no dinner at the 1944 Founder's Day ceremony and traveling was restricted to sporting events and field trips.

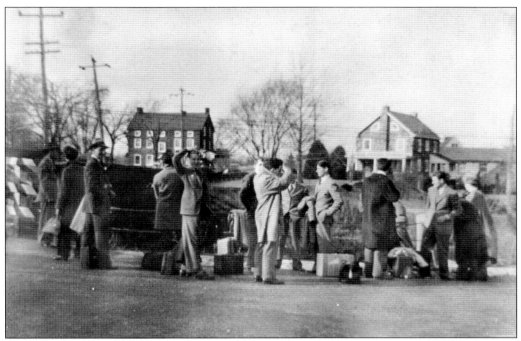

Young men wait in Media for a bus that will take them to Williamson in the 1940s. In September 1944, only three members of the senior class returned to school for the new academic year; the rest were in the service. The freshmen that year ranged in age from 15 to 17.

While sports have always been an important part of life at Williamson, the varsity and club teams were depleted because so many students were away in the war. This photograph of "Willie Tech" football players is from the early 1940s.

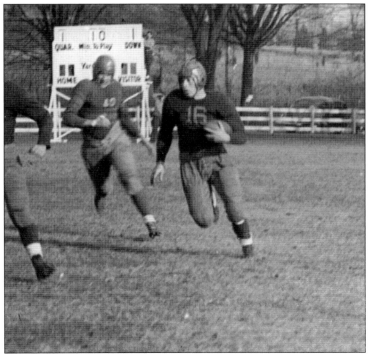

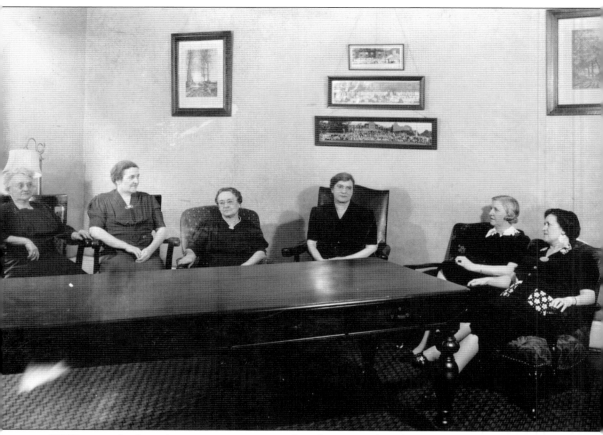

Williamson's dormitory matrons pose for this c. 1942 photograph. Students were especially fond of Sarah Sharpless, pictured at far left, whom they called "Aunt Sarah." Sharpless worked at Williamson from 1904 to 1948. When she retired, the school offered her campus housing, but she declined, choosing instead to live with her sister in Kennett Square, Pennsylvania. In 1926, Edward Steel, who had graduated in 1921, visited campus and was very happy to see his "Aunt Sarah." Though he is referring just to Sharpless in his article in the *Williamsonian*, Steel's memory of her probably speaks to many of the matrons: "It isn't very often that we have the opportunity of saying a few words of praise about the folks who mothered us during our stay at School, but I want to say right now that, were it not for Aunt Sarah's cheery smile and forgiving nature, many a geezer [a self-deprecating term for Williamson students] would have led a tougher life than he actually did." Sharpless died in 1950.

George Heckler's dormitory room at Williamson is seen here in 1942. Spartan even by the standards of the day, Williamson students were expected to keep their rooms clean and orderly at all times. Their rooms were—and still are—subject to spot inspections.

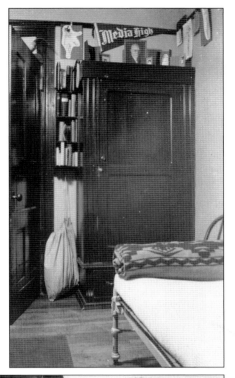

Student workers are completing a campus construction project in this photograph from the 1940s. The mechanical and industrial skills that Williamson students possessed were extremely valuable during wartime. In World War II, many Williamson men chose the Navy Seabees or the Army Corps of Engineers, given the training they had received at school. The routine of military life was definitely not intimidating to Williamson students.

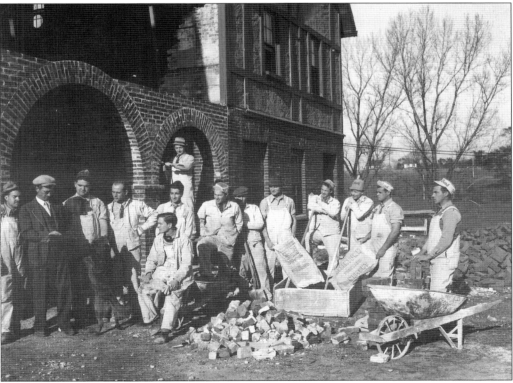

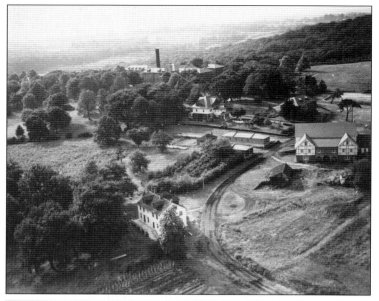

The Williamson campus is shown from the air in this 1940s photograph. The agriculture barn, which had been renovated by the time this photograph was taken, appears at right. In June 1942, the Army Air Forces, which had foreseen a need for trained aviation mechanics, established a special school at Williamson. The program required students to attend program-specific classes six days a week.

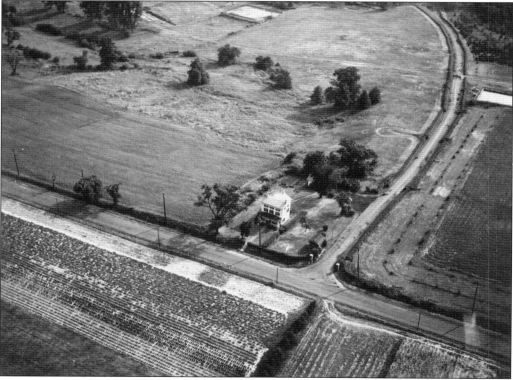

This aerial view from 1943 displays Middletown Road and Williamson's North Drive, which leads directly into campus (right). Barely visible at the intersection are two poles marking the school's entrance, as well as a small guardhouse. The Army Air Forces program included physical training and drill, as well as daily marching, calisthenics, and an obstacle course, in addition to classes, lectures, and relevant movies.

These photographs of campus life in the early 1940s reveal the young men in pensive and thoughtful moments. The war had to have been on their minds. Sixteen Williamson men died in World War II, including William F. Leathers, class of 1943; Clair I. Carl, Edward Nuneviller, and Lynnwood W. Smith, class of 1938; Charles E. Lutz and Kenneth B. Smith, class of 1939; Edmund E. Lilly, class of 1941; Earnest C. Baker, Bruce A. Malenke, and Alfred A. Smith, class of 1942; Wayne I. Griffith, Ray E. Gruber, Gail MacDonough, and Kenneth Muthard, class of 1943; and Joseph Flemming and William C. Taylor, class of 1945.

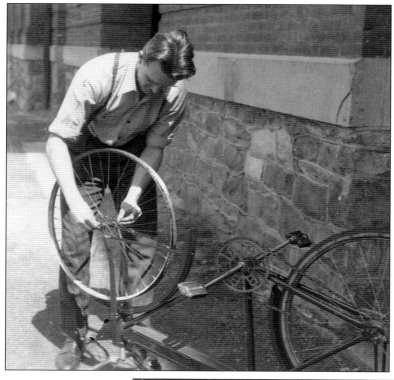

A student repairs his bicycle in this photograph from the early 1940s. Despite the war, life went on at Williamson. In June 1944, roof repairs were completed to the Main Building and several of the cottages, and the final dance of the year was held. That fall, 60 freshmen reported to campus as the class of 1947.

A student studies in his dormitory room in this 1942 photograph. The skills of Williamson students would be in high demand even after the war ended. Supt. William H. Krell told the graduating seniors in 1943 that "the knowledge and skills acquired here will help you meet the post-war problems with confidence in your ultimate success."

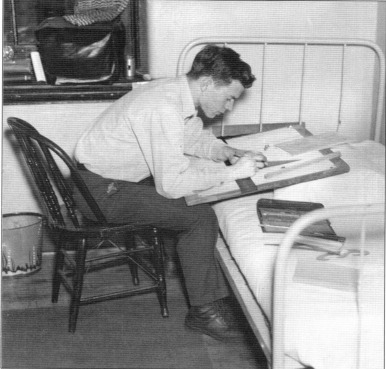

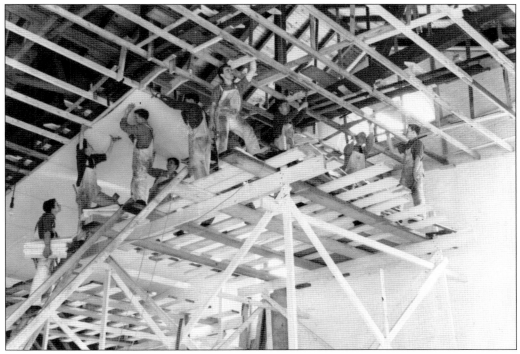

Students in this 1943 photograph are making major renovations to the old agriculture barn. The original caption for the picture states, "Hanging ceiling in old barn, May 26, 1943." Although the agriculture program had been discontinued long before, the barn remained an impressive structure on campus. The 1938 yearbook refers to it as a "massive beauty."

Students from the carpentry shop work on the flooring of the barn during renovations in 1943. The goal of the project was to transform the former horse barn into a multiuse facility. Its new name would be Alumni Hall.

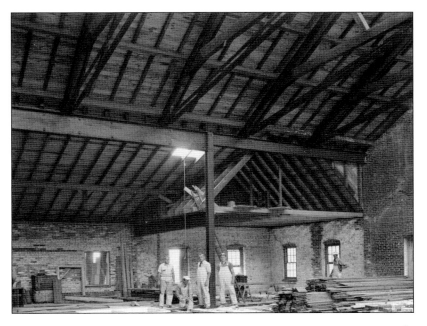

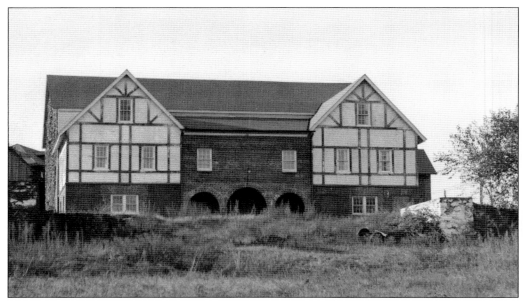

The exterior of Alumni Hall would keep its "Tudor and stucco appearance," which was original to the old barn. In 1994, the *Williamsonian* reported that George F. Heckler had discovered that Alumni Hall was so named after alumni donated $16,595 in 1941 for the building to be renovated from a horse barn to a gymnasium. This 1943 photograph shows Alumni Hall after renovations were complete.

This is another 1943 view of the new Alumni Hall. In the 1990s, the structure would find yet another life when it was renovated once more and became the home of Williamson's horticulture program. At this time, Williamson students again worked alongside contractors and performed much of the work.

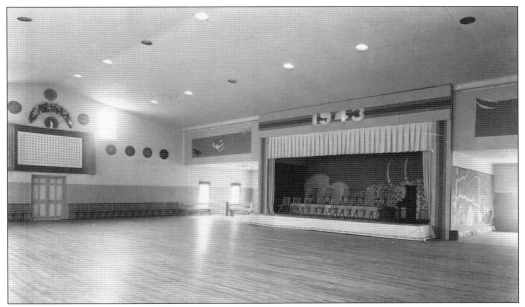

The finished interior of Alumni Hall was photographed in 1943. In the 1980s, the Main Building underwent major renovations; during that period, furniture, books, files, and other objects were stored in Alumni Hall. In order to move them back to the Main Building, students formed a human chain between the two structures and moved everything back by hand.

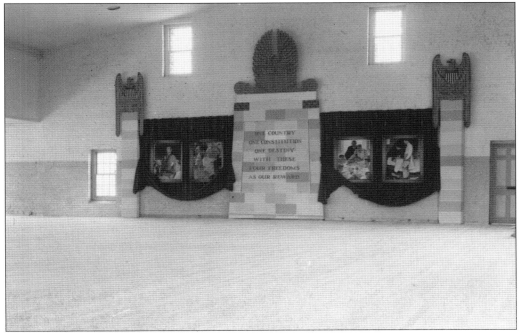

The finished interior of Alumni Hall included patriotic themes, as evidenced in this June 1943 photograph of American eagles flanking the Four Freedoms. The inscription reads, "One country, one Constitution, one destiny with these four freedoms as our reward."

These Williamson paint shop students are completing a campus project under the supervision of their instructor. The original caption of this photograph reads, "Dec. shop—Bud Johnson, Instructor, and his boys, circa 1945." By then, American men had begun to come home from the war and a sense of normalcy slowly returned to campus. The war had left a mark, however. Among those Williamson men who did not return home were Ray Gruber and Wayne Griffith, both from the class of 1943. Gruber was killed in France on December 11, 1944. Griffith graduated along with Gruber and had been his roommate at Williamson. Griffith was wounded in Belgium on January 4, 1945, and died 11 days later in a French hospital. According to the *Williamsonian*, Gruber had been an infantry scout and Griffin a paratrooper. "They were both roommates at Williamson and now they are buried in the same cemetery in France," a student editor wrote. It was time for Williamson to mourn its losses and look to the future.

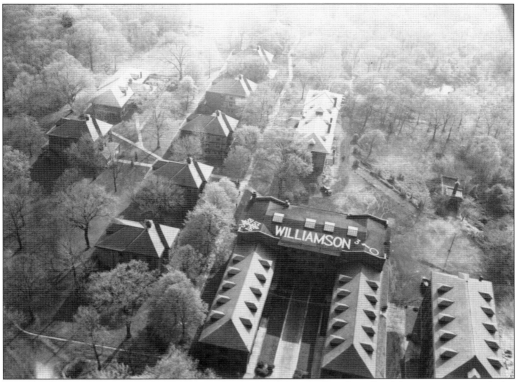

This 1947 aerial view of the Williamson campus shows the shop building (center) and the dormitories (left). By 1946, twelve students had enrolled at Williamson under the GI Bill, a government program that paid for the education and training of veterans. The school also provided refresher courses for students whose education had been interrupted by military service.

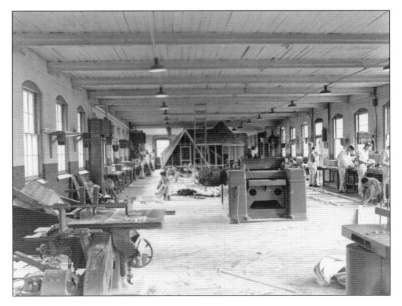

Returning veterans once again got busy in places like the carpentry shop, pictured here in the 1940s. "For the first time since the beginning of the war, the Williamson Free School of Mechanical Trades begins a new year with an almost normal enrollment," writes a student editor in the September 1945 *Williamsonian*.

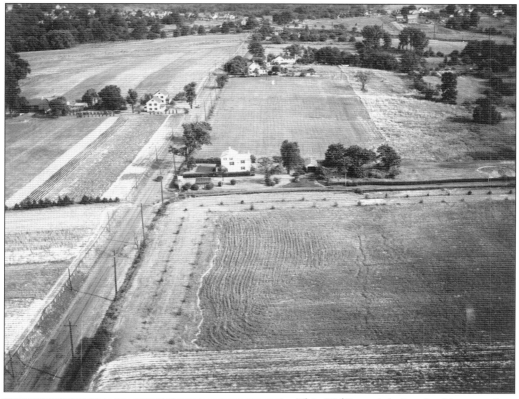

This 1940s aerial view looking south shows Middletown Road, toward the city of Chester. North Drive is in the middle of the photograph and leads into campus, which was to the right. Now a major artery also known as Route 352, Middletown Road was little more than a country road in the 1940s.

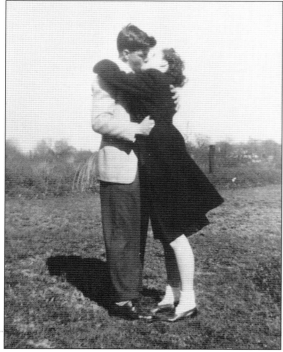

Thomas M. Mullin, a carpentry student in the class of 1947, and his friend Betty Burnett share a moment of optimism on Williamson's campus in this 1946 photograph taken by George Heckler. The original caption makes clear: "Specially posed for the carpentry shop. Not done on shop time and not recommended to be practiced on the job."

# *Five*

# CRISIS AND RENEWAL
## 1950–1970

During the 1950s, Williamson students were not allowed to have cars on campus, were still indentured to the board of trustees, and needed parental permission to leave the school on weekends. Every meal was a mandatory sit-down affair, and the campus had one small television for the entire institution.

The 1950s saw a war in Korea that would cost the life of a Williamson graduate serving in the US Army. In 1957, a devastating fire would destroy the shop building and all of the tools, machinery, and equipment within. In the fire's aftermath, it appeared that Williamson might have to close its doors forever. Only a herculean rebuilding effort—made possible by alumni, friends, and local companies—allowed the school to remain open. The fire led to the creation of the John Wanamaker Free School of Artisans, which resulted in the construction of a science building and four new shop buildings. From the day of its dedication in 1959, the Wanamaker Free School of Artisans has been an essential part of Williamson Free College of the Trades.

In the turbulent 1960s, many Williamson men would serve overseas with the military; two Williamson graduates would be killed in action in Vietnam. Other examples of Williamson members serving in Southeast Asia included Robert S. Bye, class of 1963, who earned the Silver Star, and Maj. Karl Leuschner, class of 1951, who earned the Distinguished Flying Cross and an earlier citation for bravery. Back home, Williamson's administration made clear to students that they could not participate in the prevailing counterculture. Students were reminded to keep their hair short and refrain from the use of recreational drugs, which could get them expelled. Despite the temper of the times, Williamson stayed true to its core values. In 1967, a student wrote that "of sixty-three graduates last year," 19 had entered the service. "How very fortunate we are to graduate from a school which teaches us respect, responsibility, and discipline," he concluded.

Seventy-five freshmen arrived at Williamson in the fall of 1950. Students like this young man at his drafting table in the early 1950s were still indentured to the school, and any student wishing to leave campus for a weekend had to get written permission from his parents.

This photograph shows a drafting class at Williamson in the 1950s. Note the professional appearance and demeanor of every student. In the 1950s, students were not allowed to have cars on campus, so many made "agreements" with local property owners to keep their cars nearby.

These students are at work in the machine shop in the 1950s. Williamson students completed construction projects both on and off campus, grounds and building maintenance, and even provided most of the power to the campus until the 1970s.

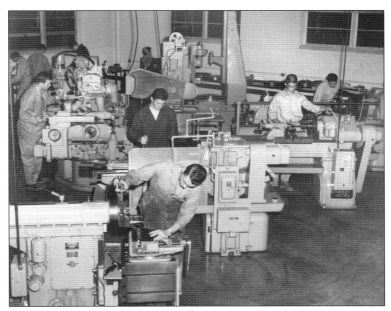

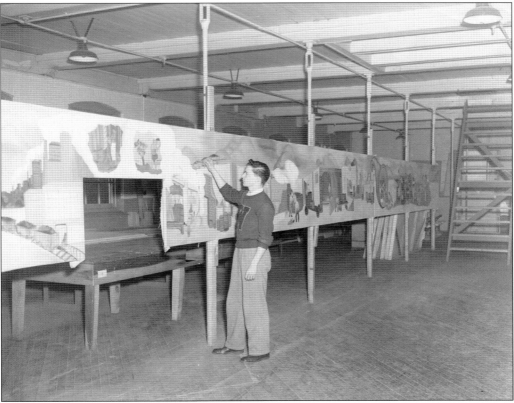

In this photograph from the 1950s, a decorating student completes a mural. Young men like this still had to worry about being drafted, especially after North Korea invaded South Korea in June 1950.

Instructors Harry Park and Ted Dickson supervise a student who is performing campus construction work in this c. 1950 photograph. During the 1950s, Williamson's board of trustees raised teacher salaries in a continuing effort to attract top educators.

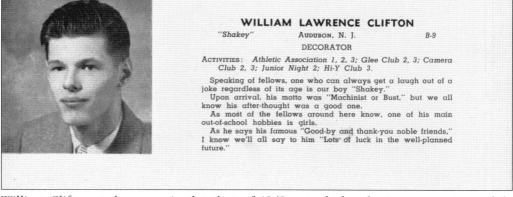

**WILLIAM LAWRENCE CLIFTON**

"Shakey"          AUDUBON, N. J.          B-9

DECORATOR

ACTIVITIES: *Athletic Association 1, 2, 3; Glee Club 2, 3; Camera Club 2, 3; Junior Night 2; Hi-Y Club 3.*

Speaking of fellows, one who can always get a laugh out of a joke regardless of its age is our boy "Shakey."

Upon arrival, his motto was "Machinist or Bust," but we all know his after-thought was a good one.

As most of the fellows around here know, one of his main out-of-school hobbies is girls.

As he says his famous "Good-by and thank-you noble friends," I know we'll all say to him "Lots of luck in the well-planned future."

William Clifton, a decorator in the class of 1949, was declared missing in action while in combat near Usan, North Korea, in November 1950. He was presumed dead in 1954. While at Williamson, the Audubon, New Jersey, native was in the glee club, the camera club, and the athletic association. His body was never recovered. Clifton was a member of the 1st Cavalry Division.

Carpentry instructor Fred Heckler poses with some of his students in this 1952 photograph. Pride and camaraderie are evident on their faces and in their body language. In 1958, the board of trustees judged that the student indentures were illegal under Pennsylvania law.

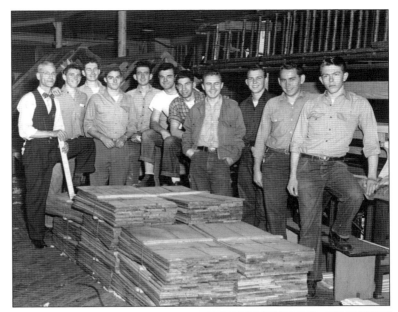

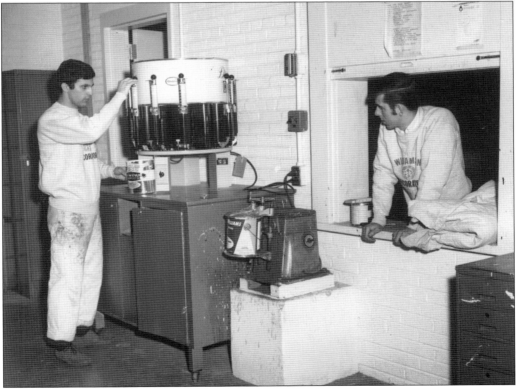

In this photograph from the late 1950s or early 1960s, decorating students prepare paint for the next job. The campus had one small black-and-white television for the entire student body; by 2002, every cottage had its own color television and there were three big-screen projectors on campus.

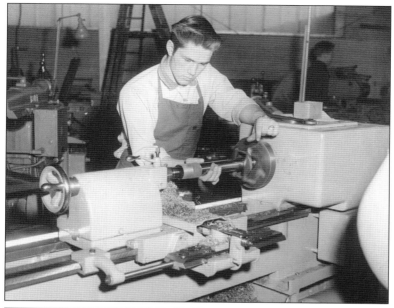

This student is the very picture of concentration in this photograph of the machine shop in the 1950s. Williamson's reputation depends on its students' training and skill and also on their maturity and sense of responsibility. Word gets around very quickly in the trades, and the students understand that.

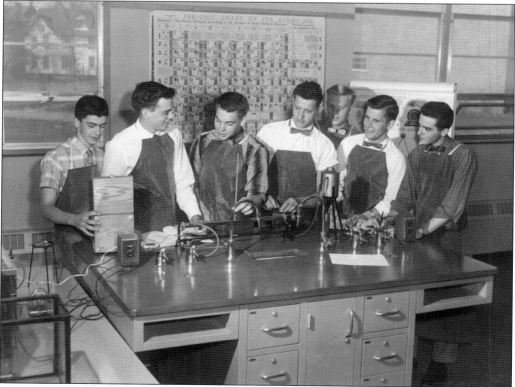

These students are shown in the chemistry lab in the 1950s. The class of 1950 was the last one to receive a free suit from the school. That had been a custom since Williamson's founding, but it was later replaced by a clothes closet from which needy students are supplied with men's clothing that has been donated.

In this c. 1950 photograph, these masonry students stand proudly next to their projects in the shop building. In the early 1950s, the *Williamsonian* staff criticized student council for "meeting only once that school year." The editors felt that some council members were reluctant to exercise their authority for fear of being called a "big deal" by fellow students.

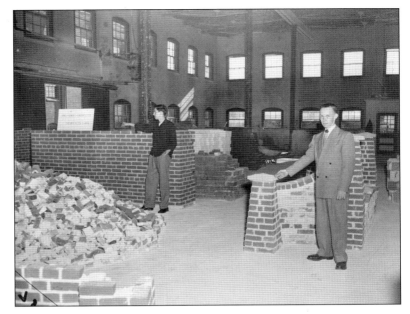

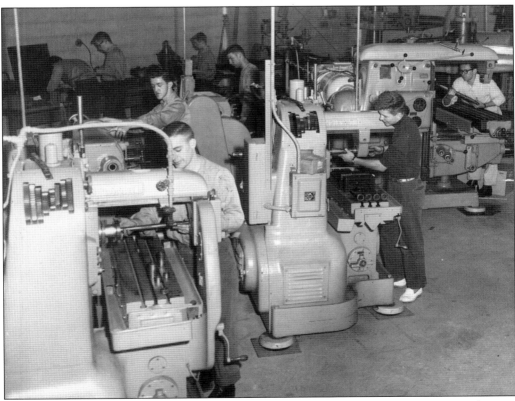

In 1957, a massive fire started in the shop building and destroyed all of the machinery, tools, furniture, and equipment within. This photograph shows the machine shop in the early 1950s and provides an idea of what was lost in the fire.

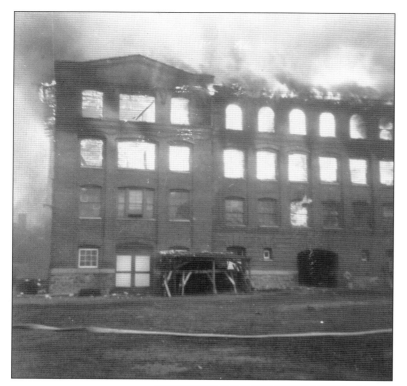

On the morning of February 25, 1957, two students noticed smoke coming from windows in the shop building. Within hours, the entire structure and everything inside was destroyed. Fortunately, no one was injured or killed, but the structure, which stood for decades and educated generations of young men, was gone in an afternoon.

The Media Fire Company responded to the fire of 1957, which reduced the shop building to a pile of ashes in an afternoon. Williamson's own small fire brigade of two seniors from each shop, supervised by power plant chief engineer Harry Park, fought the blaze courageously, but it was not enough. Fourteen local fire companies, comprising more than 200 firefighters, eventually responded.

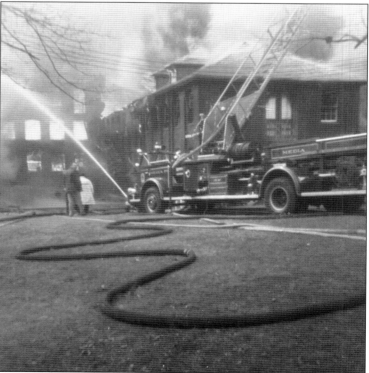

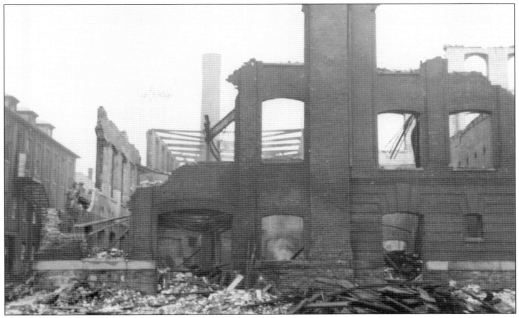

The cause of the fire was never determined, though Williamson's superintendent, William H. Krell, told the *Philadelphia Evening Bulletin* that it could have been defective wiring. Damage was estimated at $1 million (in 1957 money). The school's fire brigade, with its 1935 Auto Car fire truck, Chrysler pumper, and 600 feet of hose, was no match for this fire.

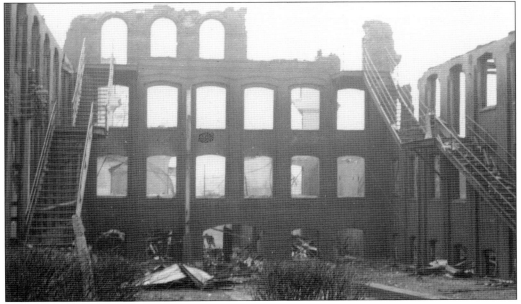

Williamson's 134 students quickly joined the fight and formed bucket brigades, but the fire was out of control very quickly. Five students were trapped on the second floor by flames, but they were able to escape by climbing down ladders. The blaze had been so intense that firefighters stayed on the scene until 10:30 that night, just to keep an eye on the smoldering embers.

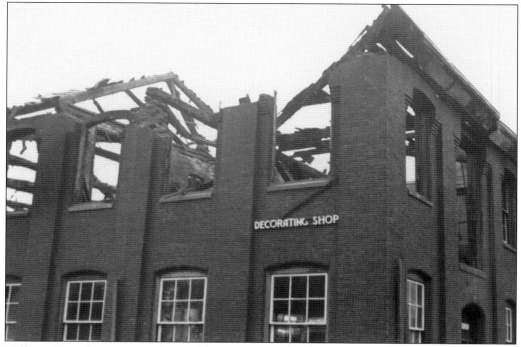

William Heverly was a student in 1957. In 2015, he described the fire to archivist Lesley Carey: "The students had just been dismissed from lunch. Sunny Miller looked at the back of the shop building. Mr. Johnson's office, deck instructor, was on the second floor and had smoke coming out of the windows. Eleven companies responded to the fire. They had a hard time getting to the fire because of the roads. Water was sucked out of the pond at Williamson, fish were sucked into the hoses. Four students . . . were rescued from the bathroom by Williamson's truck. Sand in buckets on the shop walls did not help. The contractor Mr. Eldridge had a crane and took down the remains of the building, he almost pulled it down on his crew. The salvage crew came during the day."

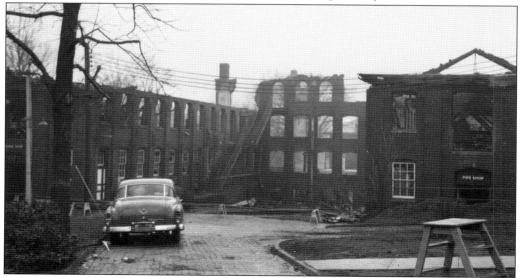

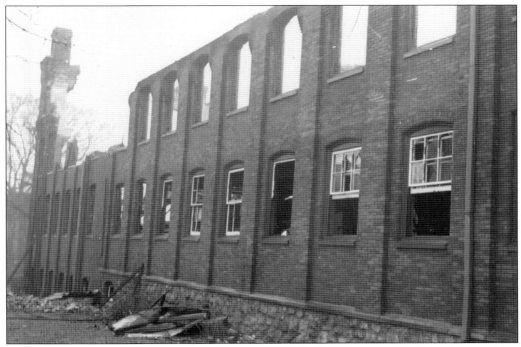

Williamson College of the Trades had faced many challenges in its existence, but nothing remotely like the loss of its shops and equipment. School officials emphasized that Williamson would go on, but there must have been some doubt as they gazed upon the burned-out shell of the shop building and the blackened remains of their tools, instruments, and gears.

Everything had to be written off because insurance alone could not come close to replacing the losses. Williamson's closure was a distinct possibility, and the future could have been as bleak as the gutted building.

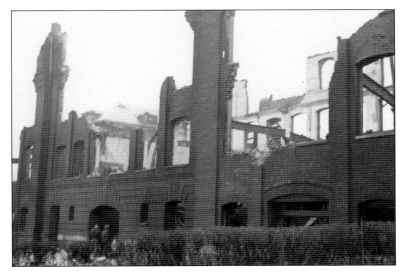

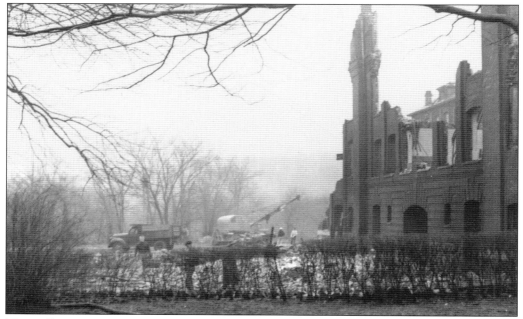

The Williamson community pulled together. The shops were relocated and began working under "emergency conditions." Some of the new shop locations included the bus garage, the library, the basement of the gym, and the laboratory. Local companies and individuals donated money, tools, and equipment.

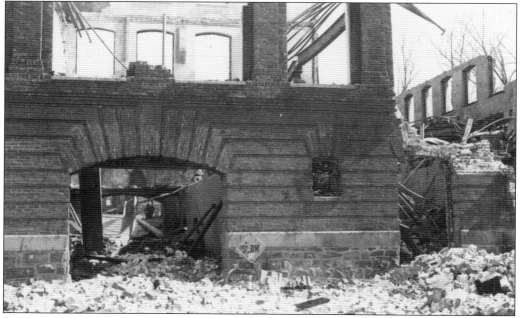

Rebuilding began immediately, and help came from many quarters. Within just a few weeks of the fire, alumni had donated $16,000, plus tools and equipment. The Commonwealth of Pennsylvania donated surplus equipment, while companies large and small stepped up to help. Many donations were unsolicited.

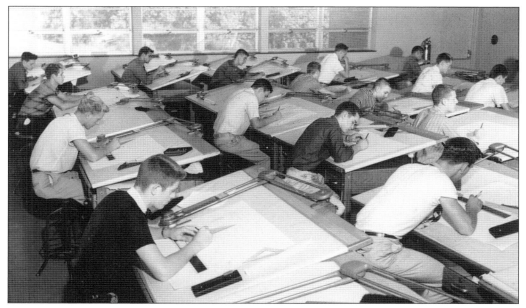

Pictured here is a drafting class in 1959. Classes had never stopped. In a March 1957 issue of the *Williamsonian*, student John Koons notes that the "carpentry shop lost everything, including all notes, drawings, and tracings. . . . We have not stopped, and the school is continuing as usual. Although greatly handicapped, everyone is cooperating, and we are plugging away in the basement of the new gym."

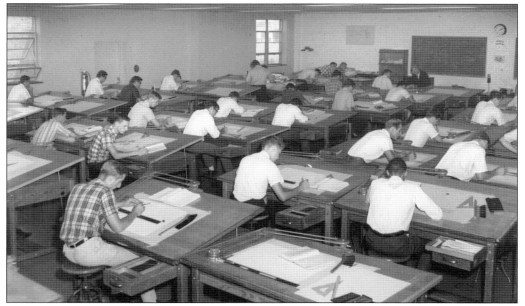

The equipment in this photograph from around 1960 was necessarily new. Right after the fire, Williamson president James R. Clemens wrote, "A new Williamson has emerged from the dense clouds of smoke that hovered over our campus during that bleak day in February. A new spirit is present with determination to not only replace the buildings that were destroyed, but to build a better Williamson."

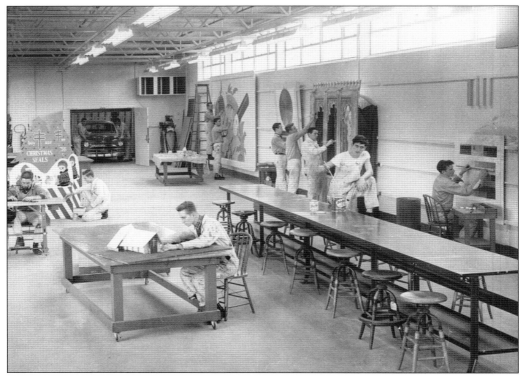

Decorating students work on a project in this 1959 photograph. The most important part of the rebuilding came when the John Wanamaker Free School of Artisans was created on the Williamson campus. This paid for the construction of an education building and four new shop buildings and added to the school's endowment. The funds were provided by the trustees of the Rodman Wanamaker estate.

Students are shown in a chemistry lab in 1960. The Wanamaker trust fund was not to be released until it had reached $2 million, but in the wake of the fire a judge allowed the fund released at $1,854,237 in order that construction could start on the new buildings. As a result, Williamson was able to forge ahead on its rebuilding plan.

In this photograph from the early 1960s, an instructor and students check on the scale model of a new faculty home, further proof of the school's vitality. "The equipment in our shops will be as good and in some cases better than that which we lost," officials announced soon after the fire.

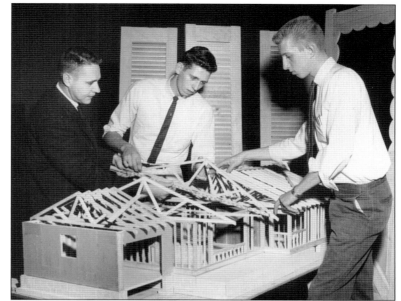

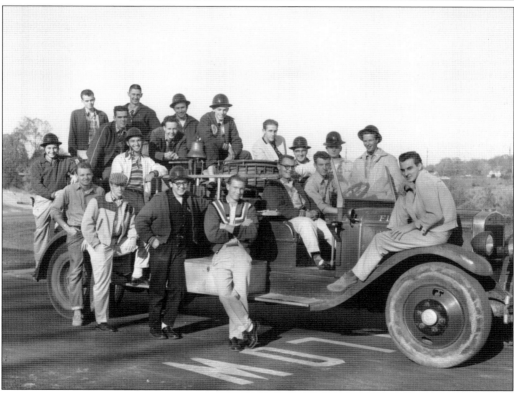

Students gather around the Williamson fire engine in this early-1960s image. The John Wanamaker Free School of Artisans was dedicated on October 24, 1959. Williamson had emerged from the ashes of February 1957 and could continue to serve young men like those pictured.

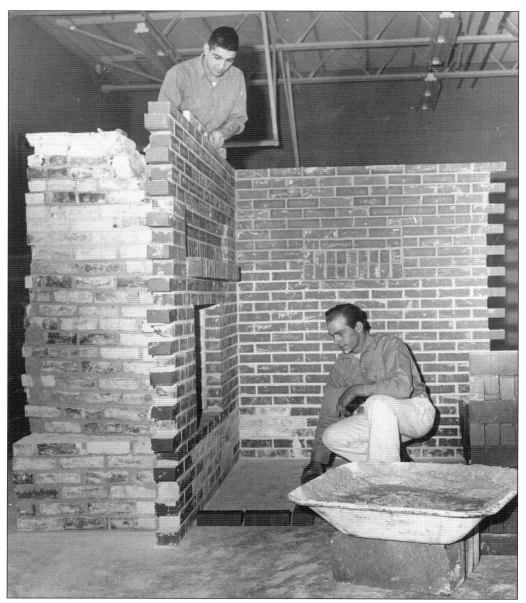

Students are at work in the brick shop during the 1950s. The importance of the Wanamaker Free School of Artisans was not lost in the following years. In 1966, an editorial in the *Williamsonian* called the creation of the Wanamaker School the "finest thing that has happened to the school (Williamson) since it was founded. Four new Shops and a Science Building were provided and, equally important, $1,200,000 of endowment funds provide Williamson with an additional income in excess of $50,000 per year." The new facilities were just in time, as John F. Kennedy became president of the United States in 1960. The Kennedy administration stressed the importance of education and progress, common themes in America at the time, especially because the United States was locked in an enduring Cold War with the Soviet Union. Education, industry, and science were being stressed in both countries.

Students in the early 1960s get a taste of business by running the campus store. As seen in the photograph, they are selling primarily candy and Williamson merchandise. Cold drinks are probably in the refrigerator behind them.

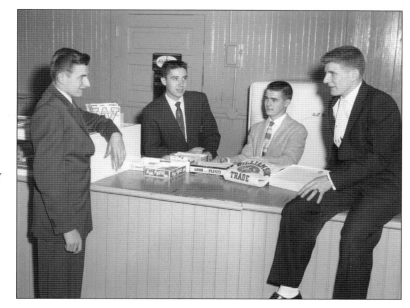

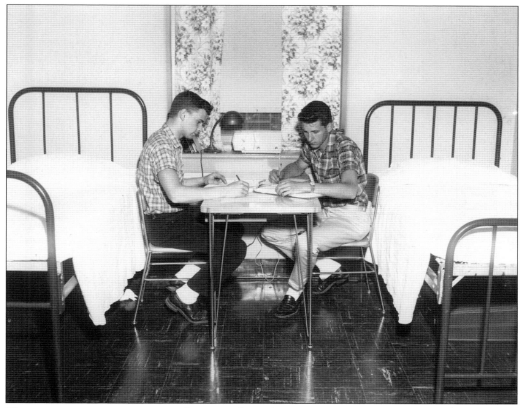

These two young men are studying in their dormitory room in a picture taken around 1960. There were not many distractions to be found in a dorm room at Williamson. Note that the room is spotless (other than a tissue on the floor) and the beds made.

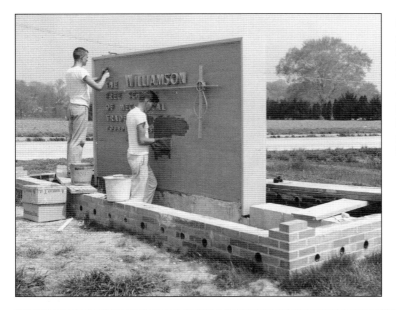

Students work on the new school sign at Middletown Road and North Drive in 1960. This kind of work, which has always been performed by Williamson students, gives them invaluable experience.

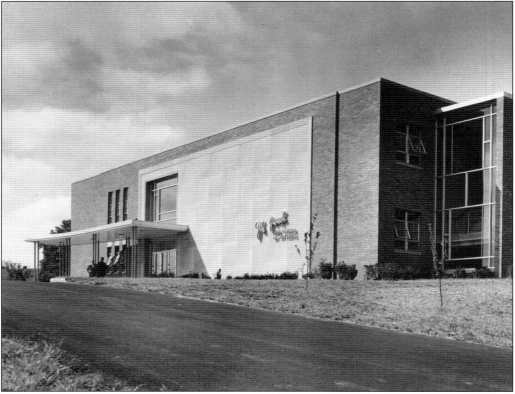

The John Wanamaker Free School of Artisans is shown here in a photograph taken around 1960. The creation of this school allowed Williamson to survive the catastrophic fire of 1957 and move into a new era. Had it not been for the Wanamaker funding, the school might well have closed its doors.

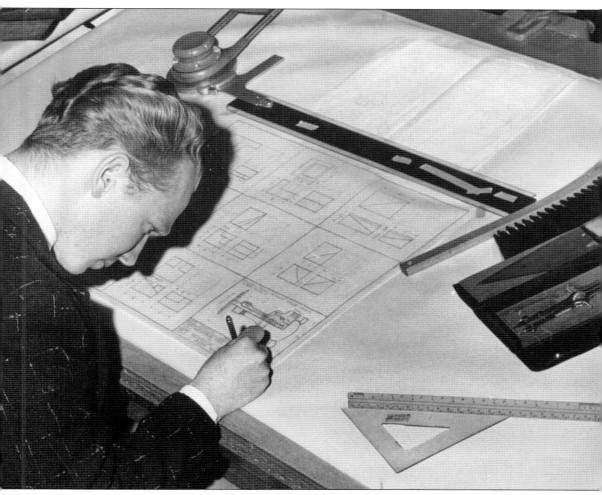

A student concentrates on his work in the drafting room in a photograph from the 1950s. There were some who opposed the Williamson-Wanamaker agreement because they said it violated the founding deed, but most alumni were on board, as were the trustees of both endowments. In the fall 1971 *Williamsonian*, Alumni Association president Donald L. Kemper, class of 1954, addresses that criticism when he writes: "Being graduates of the school doesn't give us the right to tell the administration or the Board of Trustees how to run the school. There were some changes to the Deed of Trust made with much aforethought to maintain economic balance. But the basic philosophy or objectives of the school were never altered. Also I see no place in Mr. Williamson's Deed of Trust appointing alumni overseers. Mr. Williamson's trust gave me an education, but without the administration and Board of Trustees to navigate this trust over the years, my education would not have materialized."

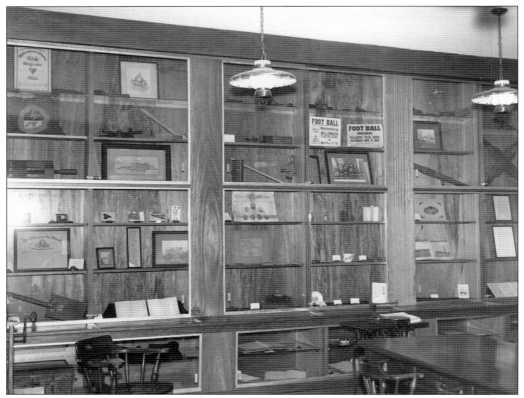

This photograph from the late 1950s shows Williamson's archives room, which was in the Main Building. The archives were maintained by George Heckler. In 2015, Pres. Michael Rounds announced that an archives and heritage room would be a priority at Williamson.

Williamson's sports are on display in this 1959 picture. The handgun just below the jacket is actually a starter pistol used for track and field.

Williamson's glee club poses on the steps of the Main Building, and the dance band is set up for a show. The clothing indicates that both images are from the late 1940s, but judging from the hair and the demeanor of the students, it could just as easily be the 1960s—which is remarkable in itself. Groups like the glee club and the dance band often performed off campus and for visitors to the school. During the turbulent 1960s, Pres. James Clemens emphasized to the students that their appearance was vital both for their success and the school's future. Students often expressed their opinions in the school publications.

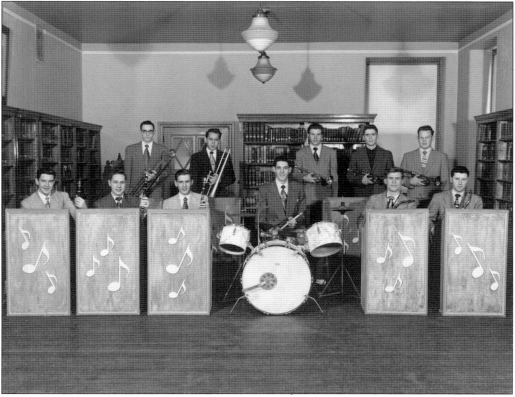

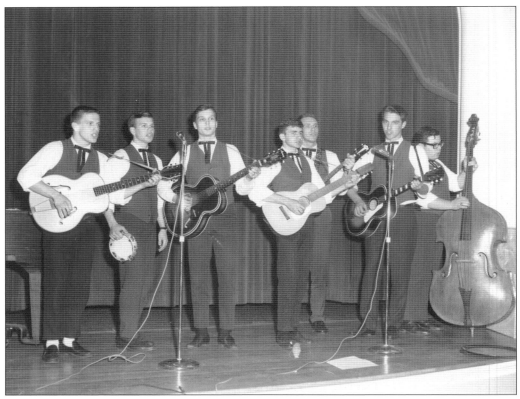

Two decades are represented here by the Tradesmen, Williamson's band. Students wear their vests and ties in a photograph from the 1950s, while the 1960s version of the Tradesmen features longer hair and a less formal style. Although styles may have changed a bit, policy remained the same at Williamson. In 1969, Pres. James Clemens gave a letter to all students in which he reminded them that the use of illegal drugs was strictly forbidden. "Students at The Williamson School using or otherwise being involved with drugs will be subject to suspension and/or expulsion or given the opportunity to withdraw from the school," he told them.

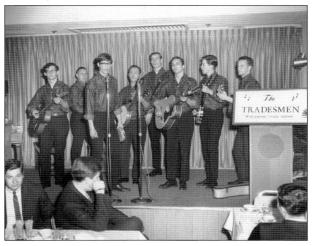

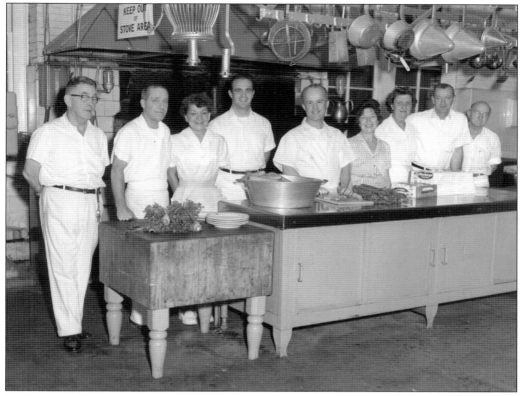

Williamson's kitchen staff poses for this photograph around 1960. The staff was responsible for three meals a day for the entire student body, as well as staff, faculty, and administration.

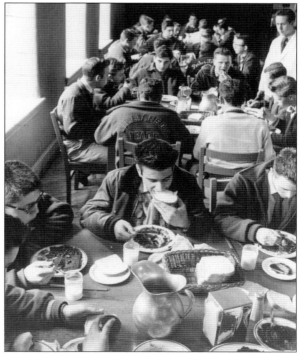

Williamson students are seen in the dining hall in the late 1950s. Oliver Smiley, class of 1933, remembered the food at Williamson fondly: "In our time the food 'Willie' put on the table was great. Coming from the farm, coal mines, and even the city, anything was better than what we had. Who could have thought we would make out so well?"

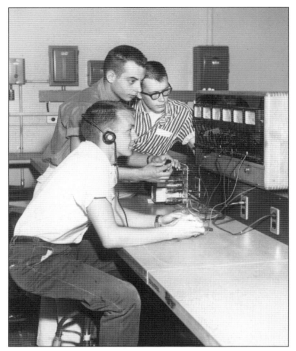

Williamson has never spared any expense to keep up with industry, a key to its philosophy of education and vital to graduates obtaining employment. In these photographs from the late 1950s, students learn to use the latest technology. In April 1961, the Soviet Union beat the United States into space, which alarmed Americans. "In Russia, 32 percent of governmental expenditures are allocated to education," wrote Pres. James R. Clemens in 1961. "While we do not agree with their methods, they are getting results which will cause very serious difficulties for America for years to come. If we are to successfully cope with this problem, we must excel in education."

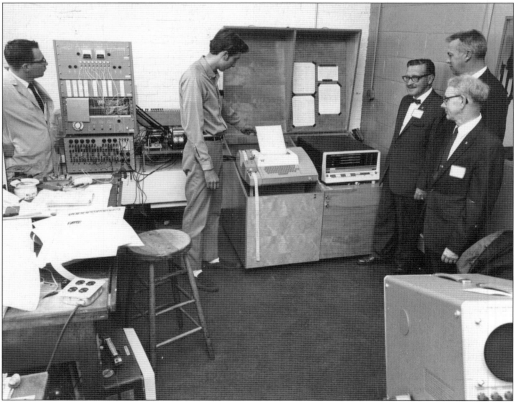

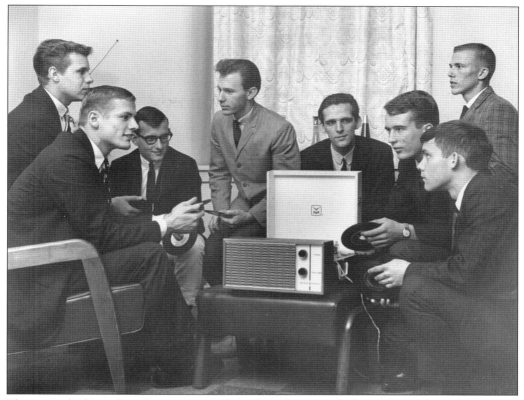

The record player has drawn a crowd in this photograph from the early 1960s, a time when both music and education were changing. Williamson president James R. Clemens wrote in 1960: "While we must continue to do superbly many of the things which are traditional at Williamson School, our new program must be patterned on changing conditions if the needs of industry and the nation are to be met."

Williamson football is shown in 1960. At that time, the only intercollegiate sports offered at Williamson were football, baseball, basketball, and cross-country. By 2002, they would include soccer, lacrosse, and wrestling.

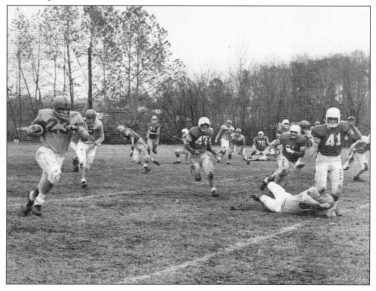

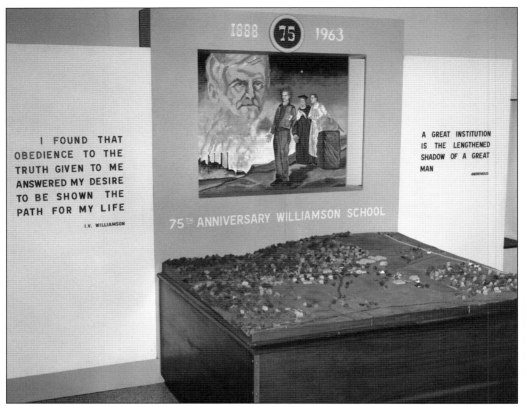

Students constructed this diorama in 1963 celebrating both Isaiah V. Williamson and his school's 75th anniversary. That year, Pres. James R. Clemens reflected the nation's optimism when he told the seniors, "This period of time, at which you are graduating, might well be called an Age of Science. We have made remarkable world progress. Whatever man can conceive, man can do."

By the early 1960s, when this photograph was taken of a student welding, Williamson's new shops were up and running. "Much new, as well as used equipment has been added to the limit of our resources," the school's president wrote. "It was acquired through purchases, from industry, Alumni and government surplus."

James R. Clemens served as president of Williamson College of the Trades from 1954 to 1979. Here, he is shown standing before a mural at the school, with an image of founder Isaiah V. Williamson over his left shoulder. Upon his retirement, Clemens, a graduate of Williamson, told the board of directors that the school was "fiscally sound" and its "greatest asset is its good name."

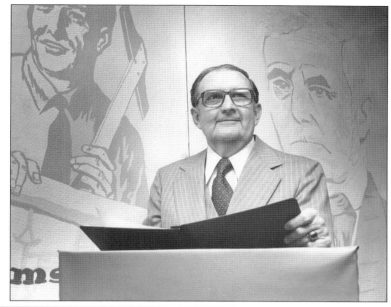

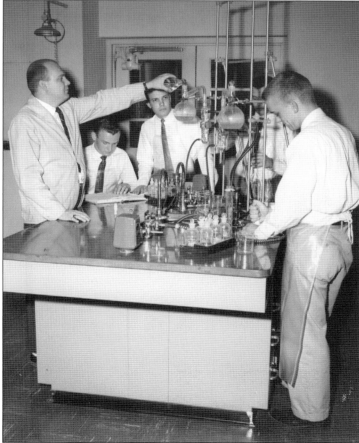

Instructor Laurie Weaver works with a group of students in the chemistry lab in 1963, at a time when the future seemed boundless. The early 1960s were a brief era of great optimism in America, before the assassination of John Kennedy and the Vietnam War took their tolls on the American psyche later in the decade.

95

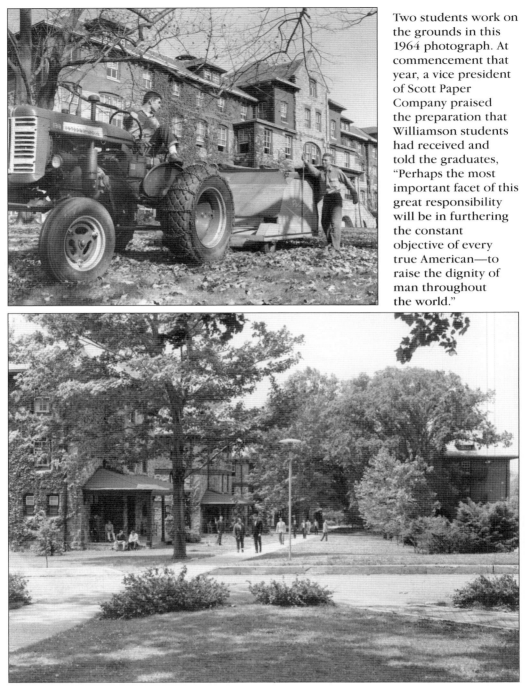

Two students work on the grounds in this 1964 photograph. At commencement that year, a vice president of Scott Paper Company praised the preparation that Williamson students had received and told the graduates, "Perhaps the most important facet of this great responsibility will be in furthering the constant objective of every true American—to raise the dignity of man throughout the world."

The cottages are featured in this c. 1965 photograph. Note that each student is wearing a coat and tie. Although the 1960s counterculture was becoming stronger by mid-decade, Williamson students still had a strict dress code and rules of conduct. Like young people across the country, they questioned such rules, but the administration made clear to them and their parents—Williamson was not like other schools.

96

Heavy equipment sits in a field during a project in this photograph from the mid-1960s. In 1965, the *Williamsonian* reported that Harry Donnelly, class of 1897, had passed away in Seattle five years earlier. Known as "the merchant prince of Alaska," Donnelly had led a rich and adventurous life. When he died, he left his entire estate, valued at $425,000, to Williamson. That was over $3.4 million in 2015 currency.

Williamson students attend class together, work together, and live together, as illustrated by this picture of a dormitory from the early 1960s. That builds loyalty and camaraderie that lasts a lifetime. Wesley K. Alfred, class of 1894, felt that way. Due to his last name, Alfred was the first person to ever receive a diploma from Williamson, and when he died in 1966, he left $14,998 to the school.

Just as when the first students arrived on campus in 1891, Williamson promised great rewards, but it would be a demanding three years. These two students are pictured on move-in day in 1966 walking up Station Drive to the Main Building.

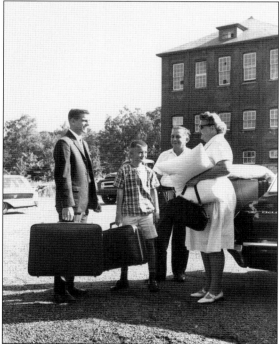

Another proud Williamson family is shown here on move-in day in 1966. New students did not have a great deal of time to adjust to their new reality, as the daily routine of inspection, chapel, classes, and shop started right away.

The school's dress code and hair code are obvious in this photograph from 1966. A year before, the first American combat troops had arrived in South Vietnam when Marines landed at Da Nang. Williamson students made their feelings about the war known, but there would be no antiwar protests on campus.

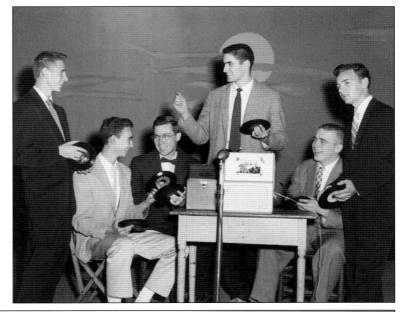

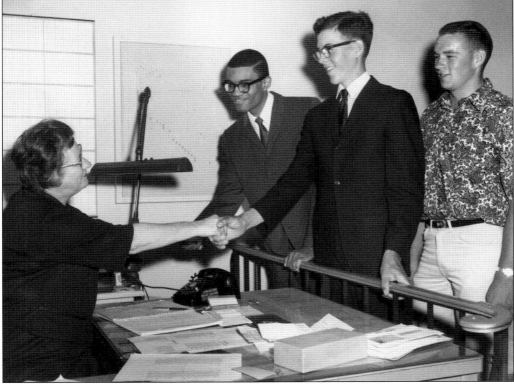

New students meet some of the school staff on move-in day in the 1960s. By this time, young men were leaving campus and entering the service, many of them drafted. A large number of Williamson men served in the armed forces during the conflict; two were killed in action in Southeast Asia.

Douglas I. Moyer of Trappe, Pennsylvania, was a machinist in the class of 1963 at Williamson. His father also attended Williamson. After graduation, Douglas attended Penn State University. He was serving as a second lieutenant in the US Army when he was killed on December 11, 1967, by small arms fire in South Vietnam. He was 26 years old. Douglas Moyer was buried in Pennsylvania.

FRED ALLEN KELLEY
"FRIGHTFUL FREDDIE"        DUNCANSVILLE, PA.
ACTIVITIES:
   Greezer Night; Junior Night; Glee Club 1,2,3; Intercottage Basketball 1,2,3; Radio Club 3.

   One of the upstate boys . . . Monday night in calculus course . . . "Old solder rims" . . . Back washed into the hotwell . . . Spent many Saturdays at the courthouse . . . Plays cards with the Housemother . . . Always found in the Rec. Room . . . Deeply rooted in the Tech. course . . . Volunteered relief from Psych. Course . . . Sunday night drags at 30th St. station . . . R. & S. period - the way to end the day . . . Old Dominion his destination.

Fred Allen Kelley was from Duncansville, Pennsylvania, and graduated from Williamson in 1966 as an electrical technician. He was killed when the tank he was driving struck a land mine in South Vietnam on July 10, 1967. He was 22 years old. He was survived by three sisters and five brothers, the eldest of whom, Ralph, graduated from Williamson in 1959. Fred Kelley is buried in Duncansville.

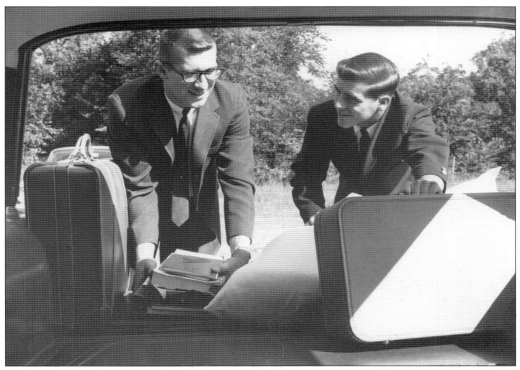

Despite war and the tumult of the 1960s, life carried on at Williamson. New students arrived each year on campus, as in this 1966 photograph of move-in day.

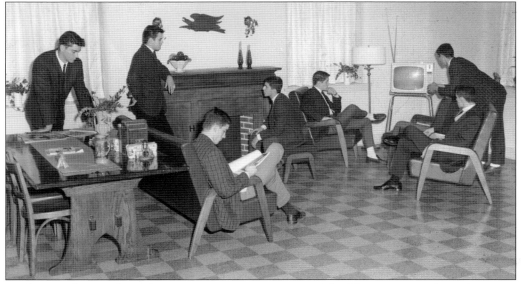

Students relax in their dormitory common area in 1967. The war must have been on their minds, as so many friends and classmates were serving. A 1966 *Williamsonian* lists five members of the class of 1965 in the military and concludes: "May God be with each and every one of you fellows who have to participate in this war, and may He bring you home safely."

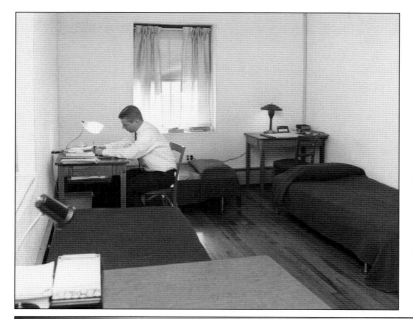

This student is studying in his dormitory room in 1967. Students used the school publications to voice their support or opposition to the Vietnam War, but there were no major outward signs of dissent. Most Williamson students were like this young man, far too busy with studies and shop.

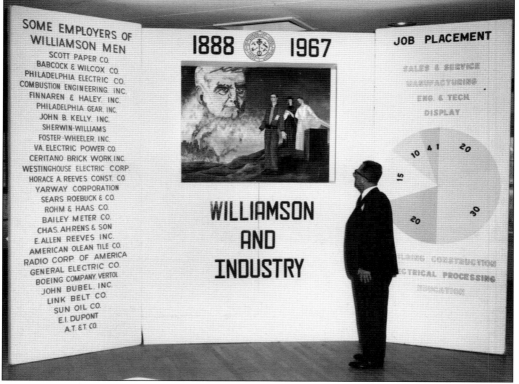

This presentation was constructed by Williamson students in 1967 to illustrate the close ties between their school and industry—exactly what founder Isaiah V. Williamson had in mind. That year, Robert S. Bye, class of 1963, was presented with the Silver Star for gallantry in action in Vietnam.

Students pose on the steps of the Main Building in 1969. The year began with a new president in office, Richard M. Nixon. That summer, Apollo 11's *Eagle* lunar module landed on the moon.

Don Day, director of development, writes in the spring 1969 *Williamsonian*: "When we read about students overrunning a college campus, it's some comfort to remember that most students, like those at Williamson, have constructive ideas on their minds." That would seem to be the case with these young men, pictured in front of the Main Building in 1969.

Brick and masonry instructor Stacey Cartledge is shown in the classroom with some of his students around 1970. Attire was more relaxed in the classroom, but Williamson students were expected to maintain a professional appearance at morning lineup, in shop, and especially when on a job off campus. As always at Williamson, there was zero tolerance for drugs and alcohol, both on and off campus. In 1968, a student wrote: "Today, in an era of chaos and confusion among many of our nation's youth, The Williamson school stands as a 'beacon' light to permanent and lasting solutions to the problems of undereducation and unemployable youth."

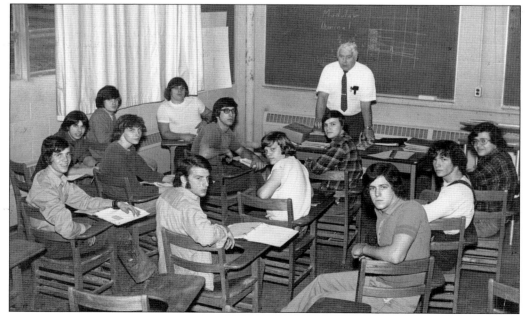

This student heads into his dormitory in 1969. His dress might not indicate 1969, and indeed, the Williamson trustees and administration made it clear that the counterculture could not be a part of their campus.

Visitors to Williamson's campus examine the carpentry shop. Williamson students have always performed many community service projects, such as renovations and new construction. These projects are a mark of the school's goodwill.

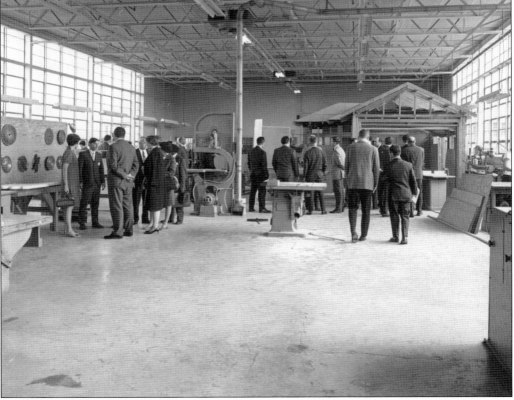

These two photographs are undated but were taken around the 1960s. In one, a Williamson carpentry student puts the finishing touches on a canoe under the direction of an instructor. Canoes were a specialty of Williamson. In the other, two carpentry students build a model staircase. The precision and craftsmanship evident in both photographs was a testament to the students and their teachers and a hallmark of Williamson. Throughout the 1950s and 1960s, two very different decades, Williamson stayed true to its core values and its mission, which was to train young men to succeed in industry and in life. As the tumultuous 1960s drew to a close, the nation and Williamson College of the Trades took a deep breath and moved into the future.

# *Six*

# INTO A NEW ERA
## 1970–1990

Williamson College of the Trades continued to flourish even in the stormiest period of American history, but like school administrators everywhere, those at Williamson must have felt a sense of relief when the 1960s were over.

In 1972, Pres. James R. Clemens sent a letter to Williamson parents reminding them that students had to conform to the school's codes of dress and conduct. "Our school is known for the quality of its graduates," he writes. "The students are clean-cut young men. Long hair, long side-burns, beards and moustaches are not permitted. Students reporting to school with hair over 4" long or dressed in 'hippy' clothing will not be permitted to attend classes or shop sessions." Clemens emphasizes that employment opportunities depended on the school's reputation. "As you know, student attitudes, appearances and outside activities are of concern to all parents. The school can only do so much. The rest is in the hands of the parents," he concludes.

In 1973, Harry Menold, class of 1913, was one of Williamson's oldest living alumni. Had it not been for Williamson, he remembered, he would have faced a life of manual labor in the sand quarries of his native Mill Creek, Pennsylvania. He felt that he owed much to the school, and recalled the discipline of those early years: "While there, we resented it very much, but today, when I look back to the school, I am very thankful for this discipline, for I feel it has been a wonderful guidance for me all through my life. I taught school for 40 years and this discipline I received at Williamson was a great help to me."

Despite Williamson's strict code of conduct in the free-spirited 1970s, applications and enrollment remained high at the Delaware County institution. That success continued in the 1980s, when the school entered the computer age and the Main Building received a major renovation for the first time since its construction. In that decade, Williamson College of the Trades also celebrated its centennial and the lasting vision of its founder.

Students relax in their dormitory in this c. 1970 photograph. Although the 1960s had ended, that decade had a long reach, and the United States would be hit with a recession in the 1970s. In 1972, Pres. James R. Clemens sent a letter home to all Williamson parents that emphasizes the school's code of dress and conduct: "By maintaining these and other educational standards, the school is able to continue to provide opportunities for weekend and summer jobs, and permanent employment for all students and graduates. Our alumni and friends continue to make contributions to the school because they know we are maintaining student standards during a difficult period for young people. These contributions are the lifeblood of the school and we cannot afford to jeopardize them. The school can only do so much. The rest is in the hands of the parents."

US troops invaded Cambodia in 1970, which led to widespread protests in America, including one at Kent State University in which four students were killed by the National Guard. The Aswan Dam was completed in Egypt, and *Monday Night Football* debuted on ABC. *Love Story* was the top-grossing film of 1970, while *Patton* won the Academy Award for Best Picture. "Bridge Over Troubled Water," by Simon and Garfunkle, was the song of the year. Back at Williamson in 1970, classes like these carried on as usual, and the school received $95,458 from five estates, or over half a million dollars in 2015 currency.

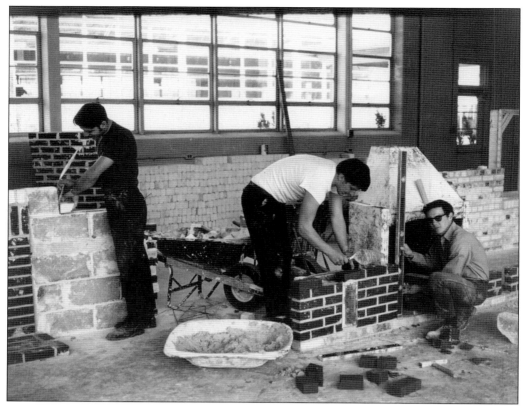

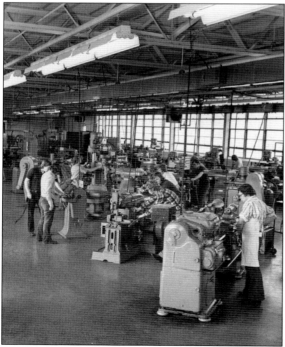

The brick shop is pictured here in the early 1970s. In 1971, at the request of the Media Rotary Club, students completed three brick walls in downtown Media, Pennsylvania. The walls display plaques dedicated to Media's World War II veterans. There is a smaller plaque recognizing the Media Rotary Club and the Williamson students who constructed the walls.

Students work in the machine shop in the early 1970s. In September 1971, heavy rains caused floods in Delaware County; one of the businesses damaged was Ahrens Lumber Yard, which had always been a friend of the school. As a result, about 40 Williamson students volunteered to help clean up the damaged lumberyard.

Painting and decorating students are busy in their shop in the early 1970s. Like all the shops at Williamson, it is clean, organized, and orderly. Numerous projects are going on at the same time.

A paint shop student finishes a mural on campus around 1970 to NBC Sports and the American Football League. The league's biggest star was quarterback Joe Namath of the New York Jets, who here gets his own portrait done by Williamson artists.

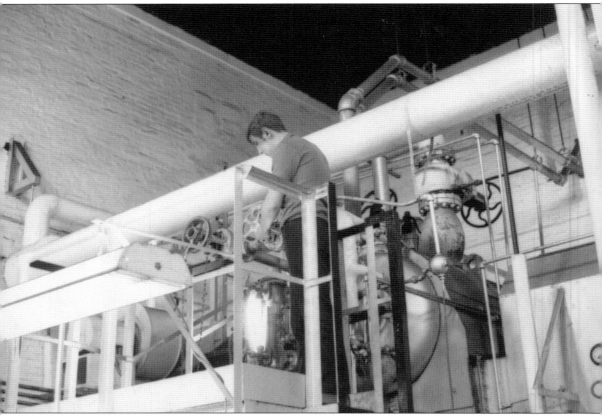

In this photograph from the early 1970s, a student is at work in the power plant. In the 1970s, the power plant still produced steam for heating campus buildings and could provide limited electricity in the event of a power outage. Also during this decade, Williamson began purchasing power from the grid, as generating its own power had become too expensive and staffing was problematic when the students were not on campus. When the power plant was constructed, it was among only 20 such plants in the United States. The steam it produced through turbines was used to generate electricity for the campus and to heat the buildings, as the steam passed through underground tunnels. By 2005, Williamson officials had decided to become an "energy island," meaning the power plant would once again meet the energy needs of the campus. Power plant students would enhance their education by again using the latest technology and equipment.

The 1970–1971 *Williamsonian* staff is pictured here. In 1971, director of education John G. Boyd stressed that everything at Williamson—classes, labs, and shops—was designed to prepare the students for continuing their education after graduation. Activities like the *Mechanic* and the *Williamsonian* helped that process.

The Williamson glee club performs in 1972. The Annual Report 1972 notes that "student enrollment increased from a low of 135 in 1958 to an average of 200 students."

Students pause in the Main Building in 1973 to check out a portrait of the school's founder, Isaiah V. Williamson. By the 1970s, many trade schools that were founded at the same time as Williamson—1888—had closed or been forced to change their educational vision due to economics.

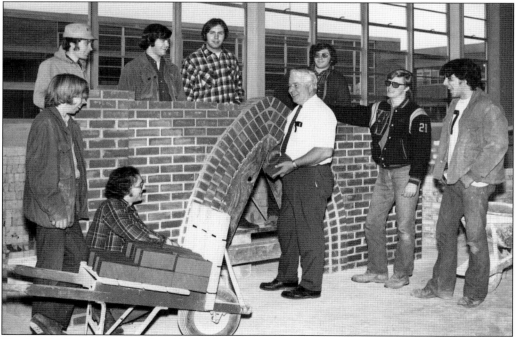

The brick shop is pictured in 1973. That year, the school bid farewell to H. Fred Heckler, who passed away in January. Heckler arrived at Williamson as a "rook" in 1913 and worked as a carpenter and draftsman after graduation. He also earned a degree in education from the University of Pennsylvania before teaching carpentry at Williamson from 1935 to 1965.

These young men are discussing music in the library in 1973. The album the student on the left is holding is *Old Ironsides and other Poems by Oliver Wendell Holmes, Read by Ed Begley*. In fact, the students probably did not listen to that album very often.

Students study in Shrigley Library in 1973. The library now holds a conference room and the Williamson archives.

Four students pose at the front entrance of the Main Building in 1973. They show the confidence and self-esteem that Williamson tries to instill in its students.

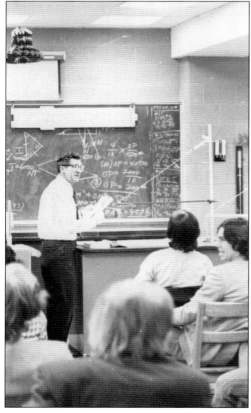

Instructor Laurie Weaver is pictured in the chemistry lab in 1974. Due to an economic downturn in the 1970s, Williamson had to manage its endowment more carefully than at any time since the Depression.

These brick and masonry students are building a fire escape on campus in 1974. The fact that students can do so much construction work provides them with tremendous experience and also saves the school money.

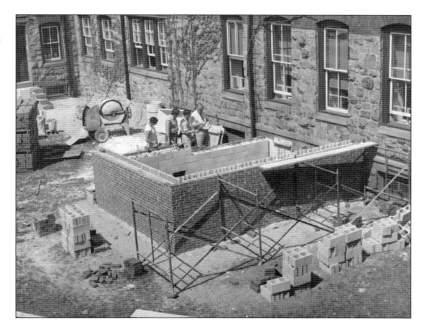

This 1975 photograph shows the junior class project that year. The school considered 1975 a "very good year" financially, as alumni contributed a then record $88,060, plus $7,651 in material and equipment.

Irene Morse, pictured here in 1974, worked in the Williamson kitchen from 1970 to 1987. Food has always been extremely important at Williamson. Class of 1933 member Oliver Smiley fondly remembered the food at school. "Williamson gave us many gifts along with our education," he wrote in the 1980s. "We had fine hospital care. Many delicious foods were made in the School bakery including homemade bread. There were pies every Friday and cinnamon buns on Tuesday." In 1985, John Felder, class of 1916, sent along his recipe for "Williamson Scrapple" and "Williamson Pork Sausage," both dated 1913–1916. Felder noted that students learned to process the food produced through the agriculture program at school. Initially, he wrote, in the dining hall the scrapple did not appear on the faculty tables—"the faculty ate the sausage and the boys and the pigs ate the scrapple." Eventually, however, the faculty did partake of the Williamson scrapple.

Students in this 1977 photograph are on their way to and from classes. Just as when the school opened in 1891, students spent half their day in the classroom learning academic subjects and the other half in the shop learning their trades.

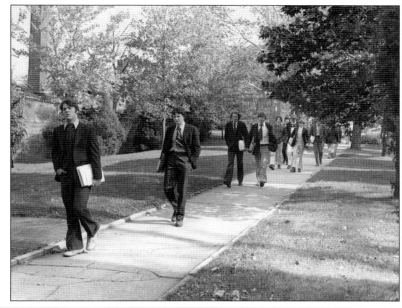

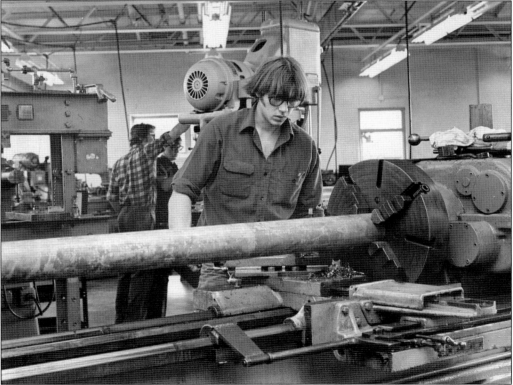

Eighty-four freshmen arrived on campus in 1977, the year this photograph of the machine shop was taken. That brought total enrollment at Williamson to 217. Seventeen of those freshmen chose machine shop as their trade, while power plant was the most popular choice at 22 freshmen.

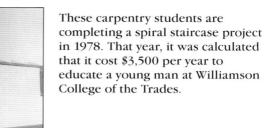

These carpentry students are completing a spiral staircase project in 1978. That year, it was calculated that it cost $3,500 per year to educate a young man at Williamson College of the Trades.

These two students are working on a weight project in the 1980s. They would need to master their trade by the time they graduated; Williamson's reputation rests on its graduates' skills and work ethics.

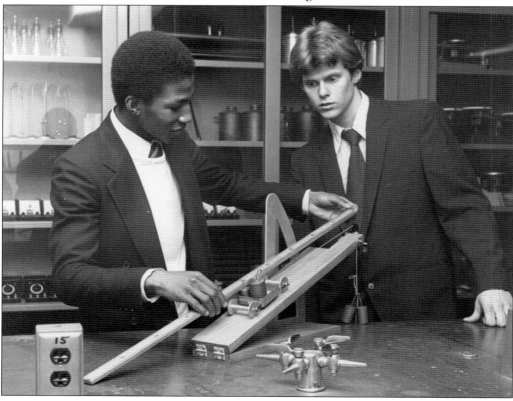

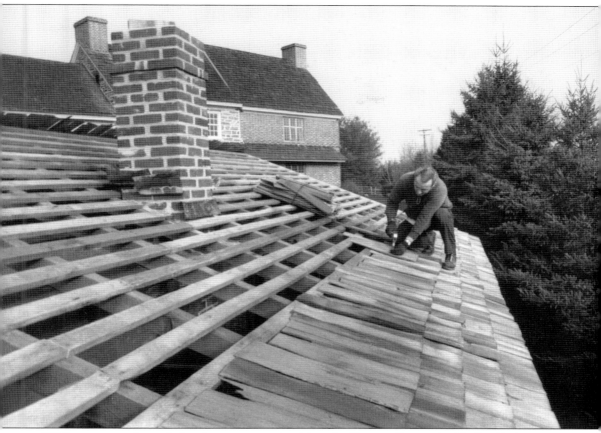

Williamson students helped to restore the historic Massey House in Media, Delaware County, in 1980. This project required producing and working with historical materials, such as wooden shingles, shown here. Williamson students, staff, and instructors have always engaged in many community service projects each year. Also in 1980, Ed Steel, class of 1921, wrote a memoir about his years at Williamson. He recalls that one of his friends helped dig graves at a local school during the influenza pandemic of 1918, and that the World War I veterans attending Williamson were known as "rehabs," since they were former servicemen being "rehabilitated" to learn a trade. The veterans lived together in their own dormitories, Steel remembers, and "would not submit to the same discipline and restrictions" that applied to the regular students. "So, conflicts in this area developed from time to time which is a story in itself."

Former Philadelphia Flyers goaltender Bernie Parent spoke to Williamson students in 1981. Here, he is shown in the dining hall. Parent was the goaltender for the Flyers when they won consecutive National Hockey League championships in the 1970s. He retired in 1979.

Bernie Parent spoke to the students about the value of safety in sports and in construction. Senior Michael Deeck tried on Parent's equipment to illustrate the goaltender's point.

# *Seven*

# SURVIVING AND THRIVING
## 1990 TO THE PRESENT

In September 1990, Williamson welcomed 96 new students to campus, the largest freshman class in its history to that point. Later that year, the administration announced a new program: horticulture, landscaping, and turf management. This was the first program added to Williamson's curriculum since painting and decorating in 1932. Fifteen students were expected to enroll each year, and Alumni Hall would be completely renovated to house the new program.

During the 1990s, there was discussion at Williamson about either repairing its old bus or buying a new one (the school eventually bought a new one for $41,000). Writing in the March 1991 *Williamsonian*, Oliver Smiley, class of 1933, remembers a similar debate that took place in 1951. At that time, the class of 1933 chipped in to buy the school a used Ford bus for $750. "The bus didn't last very long, but at least it was a start," he writes. "On one football trip, the bus was so crowded with athletes the uniforms and equipment were secured to the roof with ropes. As they went under a low railroad bridge the baggage was knocked off without anyone noticing. They had to borrow uniforms from the opposing team in order to play."

The new century began well. In 2002, renovations to the Old Infirmary were completed, as it became Smith Cottage, and the school began its Ambassadors program. Three years later, Walter Strine, class of 1929 and a trustee for many years, donated $3 million for the creation of the Walter M. Strine Sr. Academic Center.

In 2008, Williamson received the largest gift in its history when the Rowans and the Lenfests gave a combined $40 million to the school. Later in the decade, the Main Building was enhanced with an elevator, a handicap ramp, and an electric door. Students performed much of the work.

In 2009, school officials announced that Williamson Free School of Mechanical Trades was seeking to change its name to Williamson College of the Trades. This became reality in 2015, as Williamson continued to evolve and change with the world around it.

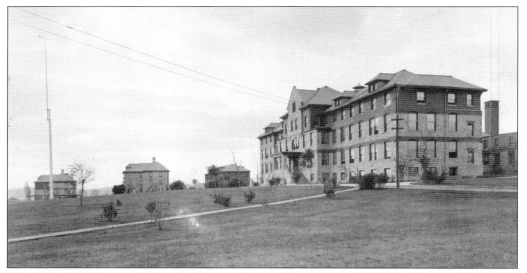

The Main Building and dormitories are shown above around 1895, with a modern view of the Main Building below. Trees now obscure the dormitories from the 1895 camera position. Note that the cupola was not part of the original construction. In 1991, the *Williamsonian* carried a memoir from Glenn Spies, a machinist from the class of 1936. Born in 1916 near Gettysburg, Pennsylvania, Spies had attended a one-room schoolhouse and later enrolled at Williamson when he was 17 years old. "I came from a poor family and would still be a poor farmer living in Pennsylvania had it not been for the Williamson School," he remembers. "Williamson means everything to me. I learned things there that I have applied throughout my life that made me what I am today; I give Williamson all the credit."

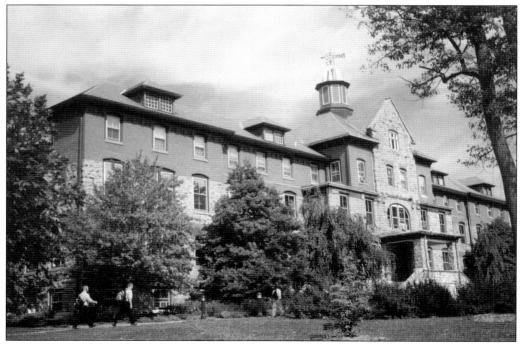

In November 2000, masonry students working in the old infirmary found a time capsule that must have been hidden away when the structure was built in 1899. The capsule was about the size of a shoebox and made of cement with a false lead bottom. This photograph shows former instructor, president, and trustee George Heckler supervising the removal of items from the capsule, with Pres. Paul Reid and several students in the background. The capsule contained the first issue of *Williamson Life* from 1899, a June 1899 issue of the *Philadelphia Public Ledger* (a daily newspaper that published from 1836 to 1942), an 1899 dime and quarter in mint condition, a sheet containing the names of trustees and students, a "Condition of Admission" statement, a school brochure, and a sealed envelope with a letter inside. Moisture had damaged the documents. The artifacts were sent to the Center for Art and Historic Artifacts in Philadelphia.

Pres. Paul Reid stands with Walter Strine, class of 1929, who at 96 was Williamson's oldest living alumnus when this photograph was taken in 2005. A trustee for many years, Strine donated large sums of money to his alma mater, including $3 million in 2005 for the creation of the Walter M. Strine Sr. Academic Center.

The cupola atop the Main Building is the subject of this photograph from the new century. In April 2016, ground was broken for Williamson's first new dormitory since 1912. The new building will be named Watson Dorm, after Wayne Watson, who graduated in 1948, joined the board of trustees in 1971, and was chairman of the board starting in 1983. He died in July 2016.

In 1888, Isaiah V. Williamson founded Williamson Free School of Mechanical Trades. On July 1, 2015, Pres. Michael J. Rounds hosted a ceremony at the school officially announcing its new name: Williamson College of the Trades. Rounds emphasized that the school's mission had not changed, but the new name would provide a clearer understanding of Williamson's purpose and place in American education. The ceremony was presided over by Rounds and Wayne Watson, class of 1948 and chairman of the board of trustees. A flag bearing the school's new name was raised, and the sign on Middletown Road, Williamson's main entrance, read "Williamson College of the Trades" for the first time. Rounds has also made another priority: the preservation of Williamson's history in an archives room, which will be housed in the Main Building. The archives will make available the history of what is certainly one of the most unique schools in the country—Williamson College of the Trades.

# Discover Thousands of Local History Books Featuring Millions of Vintage Images

Arcadia Publishing, the leading local history publisher in the United States, is committed to making history accessible and meaningful through publishing books that celebrate and preserve the heritage of America's people and places.

Find more books like this at
**www.arcadiapublishing.com**

Search for your hometown history, your old stomping grounds, and even your favorite sports team.